forgotten

TALES

of

PENNSYLVANIA

Thomas White

illustrations by
Marshall Hudson

THE
History
PRESS

Published by The History Press
Charleston, SC 29403
www.historypress.net

Copyright © 2009 by Thomas White
All rights reserved

First published 2009
Second printing 2010

Manufactured in the United States

ISBN 978.1.59629.812.5

Library of Congress Cataloging-in-Publication Data

White, Thomas.
Forgotten tales of Pennsylvania / Thomas White.
p. cm.
ISBN 978-1-59629-812-5
1. Pennsylvania--History--Anecdotes. 2. Pennsylvania--Biography--Anecdotes.
3. Curiosities and wonders--Pennsylvania--Anecdotes. I. Title.
F149.6.W47 2009
974.8--dc22
2009036415

For Justina, Tommy and Marisa

Acknowledgements

Writing any book is a time-consuming and tedious process. This book was no exception. I would like to take this opportunity to thank the people who helped and supported me while I was working on this project, especially my wife, Justina, and my children, Tommy and Marisa. Also, I want to thank my parents, Tom and Jean, and my brother, Ed, for their support. Elizabeth Williams, Aaron Carson and Paul Demilio were a great help in proofreading this manuscript. Their input and constructive comments were vital. I would also like to thank Hannah Cassilly and the rest of the staff at The History Press for allowing me to write the Pennsylvania volume in their Forgotten Tales series. Many other people made important contributions to this book in one form or another, including Tony Lavorgne, Emily Jack, Kurt Wilson, Ken Whiteleather, Brian Hallam, Vince Grubb, Renee Morgan, Brian Rogers, Brett Cobbey, Jon Halpern, Dan Simkins, Art Louderback, David Grinnell and Bob Stakeley.

Introduction

Sometimes Pennsylvania can be a fascinating state. For over a decade, I have studied the history of the state in a professional capacity in one form or another. As an archivist, curator and professor, I worked with documents and artifacts from the cradle of liberty in the East to the workshop of the world in the West. I have spent countless hours reading books and articles dealing with everything from the French and Indian War to the Cold War in Pennsylvania. But those stories are familiar to many, and that is not what this book is about. This book is about the things that you stumble across when you are researching all of the big events. This book covers the strange stuff. It is about the bizarre anecdotes, trivia, legends and mostly forgotten stories that you do not normally see in a history book; the kind of stories I, and hopefully you, like best.

Writing this book reinforced for me just how interesting— and weird—Pennsylvania's history is. For example, you

probably did not know that there were werewolves and giant snakes in Pennsylvania (at least that's what they tell me) or that there are several lost treasures hidden or buried here. You might be surprised to learn that a Pittsburgh dog once had an obituary in the *New York Times*, that a gypsy queen is buried in the Shenango Valley or that giant skeletons were excavated in some of the state's ancient burial mounds. One day, the midafternoon sky even went black over much of the state.

The tales presented here cover a wide variety of topics, in addition to the ones already mentioned. They include witches, tornados, floods, bandits, explosions, strange animals, legends, unusual people, hoaxes, meteorites, cannibals and the end of the world. I cannot say that I had any strict criteria for a story to be included. It only had to be unusual, relatively unknown to your average person and to have happened in Pennsylvania. A few of these tales may be known in one part of the state and not others. The tales were compiled from a variety of sources, including old newspaper accounts, obscure books and journals, court documents, weather reports, interviews and oral histories. I hope that you enjoy reading these unusual stories because I certainly enjoyed writing about them.

Forgotten Tales of Pennsylvania

A Bad Day at the McGrattin House

A series of bizarre accidents befell the boardinghouse of Charles McGrattin, located in Rankin, during one twenty-four-hour period in mid-July 1891. The body of twenty-nine-year-old David Bell, one of the boarders, was found in the river one afternoon. He had apparently fallen in and drowned while drunk. Two hours later, a lamp exploded in McGrattin's house, burning it to the ground and killing two of his sons, Robert and Charles. The next morning, two other boarders, Harry Rowe and Peter Knee, returned to the burned-out ruins to see if they could retrieve any of their belongings. The remains of the brick chimney collapsed on them, killing Rowe outright and severely injuring Knee. A Dr. Cope was called to the scene, and despite his attempts

to save Knee, he ultimately died. On his way home, Dr. Cope's horses darted from his buggy, causing it to crash. The doctor was severely injured, and it appeared that his wounds could be fatal. There were no follow-up articles in the newspapers revealing the doctor's fate, but given the circumstances, it looks like the odds were against him.

CANNIBALS AT THE HOTEL

When P.T. Barnum brought his traveling act to York County in May 1872, he stayed at the Pennsylvania House Hotel in the city of York. Among his entourage were four "genuine" cannibals from Fiji. His advertisement described them as "the Four Wild Cannibals, Captives of War, lately ransomed from King Thakembau by Mr. Barnum at a cost of $15,000." During their stay, one of the cannibals, who was a dwarf, became ill, refused to eat and could only be heard repeating the word "Fiji." Late one evening, when a doctor attempted to give him medicine, he fell backward and died.

The cannibal's body was placed in a casket and locked in an adjoining room until burial arrangements could be made. S.S. Smith, who was watching the body, left for less than thirty minutes. When he returned, he discovered that two of the other cannibals had somehow entered the room and were chewing on parts of the dead man. Only the fourth cannibal, a female who had been converted by

English missionaries, refrained from feasting on the corpse. The body was buried in the potter's field the same evening to prevent further incidents. One local paper, the *True Democrat*, called the story a hoax perpetrated by Barnum to capitalize on the death of one of his "performers."

JUDGE SAVES GOATS FROM FLOOD

During the Great Saint Patrick's Day Flood of 1936, much of Pittsburgh and the surrounding neighborhoods were under water. A section of Judge Michael A. Musmanno's nearby hometown of McKees Rocks was also flooded. While traversing the area known as "the bottoms" in a rowboat, the judge heard a noise. It came from a small herd of goats and their owner marooned on a rooftop nearby. The judge rescued the goats and the man in his small boat, making two trips. As a reward, the owner of the goats gave the judge a small white kid. The judge named the kid Bottoms.

GIANT SKELETONS

In 1885, a team of scientists from the Smithsonian excavated an Indian mound near Gasterville. Beneath the mound of earth was a crude stone burial vault. Inside was the skeleton of a seven-foot, two-inch giant. The skeleton was said to still retain some of its long, coarse black hair. On its head was a

copper crown or band. Nearby were the remains of several children. All were lying on straw mats and animal hides. The stones that made up the burial vault were inscribed with petroglyphs that could not be deciphered.

During the 1921 excavation of an Indian mound near Greensburg, archaeologists discovered a giant skeleton that measured between eight and nine feet tall. Dr. Holland of the Carnegie Museum of Pittsburgh was directing the opening of the one-hundred-foot-long, twelve-foot-high mound. The team also discovered a partially mummified body, which they estimated at the time to be as many as four thousand years old.

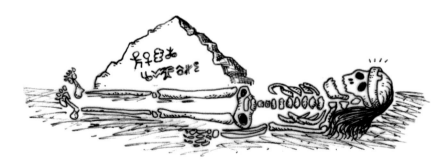

A WEREWOLF IN CLINTON COUNTY

Henry Shoemaker, one of Pennsylvania's early proponents of regional folklore, was told the story of the Clinton

County werewolf by Peter Pentz in 1900. Pentz's own aunt, a midwife, had a frightening encounter with the creature in the 1850s. One night, when she was returning home from assisting with a birth, she spotted an enormous black wolf or dog creeping nearby. When the creature noticed her, it stood upright on its hind legs and began to pursue her. She managed to evade the werewolf long enough to make it to her cabin and alert her husband. He grabbed two bullets wrapped in "sacramental wax," went outside and shot the creature as it approached him. Before their eyes, the dying werewolf turned back into one of their neighbors. He thanked them for ending his torment as he died.

An Earthquake in Beaver County

A minor earthquake was reported in Beaver County on September 22, 1886. The shaking was felt about 8:45 p.m. and was initially thought by many to be some type of natural gas explosion. The quake lasted for about thirty seconds, and though buildings swayed, no major damage was reported.

An Alligator in the Sewer

George Moul, an employee of the Pittsburgh Bureau of Highways and Sewers, made an unusual discovery on the job

in September 1927. He was assigned to fix a blocked sewer on Royal Street in the city's North Side. Moul removed the manhole cover and began to clear an obstruction when he realized that a set of "evil-looking" eyes was staring at him. After the initial surprise faded, Moul realized what he was looking at. He managed to grab the head of the three-foot alligator and drag it out of the sewer. After tying a rope to the alligator, Moul took it to his home on Lockhart Street. He and his co-workers never figured out how it got into the sewer or how it had traveled so far north.

A York Man's Healing Hands

A rather miraculous healing was reported in York County in September 1884. A former sheriff named James Peeling had taken ill with severe pain throughout his body. He could not get out of bed, so the family doctor was called. The doctor believed that he suffered from intercostal rheumatism and asked if a second doctor could be brought in to confirm his diagnosis. Peeling declined, and his condition continued to get worse. Later in the week, his brother convinced him to allow a man named Edmund Meyers to visit. Meyers was becoming known in the community for his unusual ability to heal by touch.

When Meyers arrived, he placed his hand on Peeling's forehead and ordered him to take a deep breath. Peeling said it was impossible, but when he tried, he found that it was not as painful as it had been. As he exhaled, his pain continued to decrease. By the time Meyers was ready to leave, Peeling was able to walk him to his front gate. After word got out, hundreds of people came to Meyers for relief, and many left with their own stories of healing. Meyers never claimed to have any supernatural power and did not know how his ability worked.

TROLLEY CARS COLLIDED IN FOG

The morning of September 23, 1908, was an extremely foggy one in Philadelphia. Two trolley cars loaded with workmen were making their way through the city on their usual routes. What neither of the operators knew was that the signal box that controlled the trolley traffic had been deactivated by an angry striker. When the two cars spotted each other in the fog, it was too late to stop or even slow down. They slammed into each other at full speed, sending debris and bodies flying into the surrounding street. Seven of the men on the trolleys were killed immediately. Seventy-two others were strewn about with a variety of injuries, including crushed ribs, severed limbs, broken bones, cuts and severe bruises. Several passengers died later at the hospital. The identity of the man who tampered with the box was not ascertained.

THE AFTERNOON THAT THE SKY WENT BLACK

A strange phenomenon occurred in the sky over most of Pennsylvania on Sunday, September 25, 1950. The midafternoon sky turned to shades of red, yellow and purple before turning almost as black as night. The occurrence lasted for almost half an hour, and in some areas much longer. The phenomenon caused confusion on the ground and resulted in one death.

In Tyrone, a sixty-five-year-old man was killed while crossing the street by a driver who could not see him in the sudden darkness. At Forbes Field in Pittsburgh, the Pittsburgh-Cincinnati double-header had to be played

under the lights. Two drivers in a race in New Kensington were injured after their cars crashed in the darkness. The black sky even confused animals on farms in many counties. Chickens returned to their coops to roost in the middle of the afternoon. Many other incidents were reported throughout the state.

Astronomers in Philadelphia and Pittsburgh were puzzled by the phenomenon, and none could recall ever witnessing such an occurrence before. It was believed that a heavy layer of smoke from forest fires in Canada was blown over the state because of a change in weather patterns. A few disagreed with the explanation, stating that there were no confirmed forest fires of substantial size in Canada at the time.

AWARD-WINNING SHRUNKEN HEAD

A shrunken head owned by William Gibson won a blue ribbon for "rarest exhibit" at a 1937 sportsman's show in Washington County. Gibson had acquired the baseball-sized head in the late 1920s from the Jivaro Indians in Ecuador. He traded a small mirror for the head.

OUT-OF-PLACE TIGERS

In July 1986, a series of big cat sightings was reported in Wyoming, Lackawanna and Susquehanna Counties. A

man walking along Route 92 near Nicholson spotted a large feline that looked like a tiger only fifty feet ahead of him. When it noticed the man, it darted back into the woods. The man reported the animal to the state police, who later spotted it in the woods from a helicopter. They were unable to catch it on the ground, despite several attempts.

Two days later, another large cat was spotted in a backyard in Newton Township. It was described as having orange hair. The next day, a large beige cat was spotted by a photographer in Jackson. State police were inundated with many other reports of tigers and large cats. One person even claimed to have seen a white tiger. All attempts by police and wildlife officials to locate and trap the animals were unsuccessful.

THE GRAVE OF THE GYPSY QUEEN

In the spring of 1921, a gypsy carnival came to the Shenango Valley. It ended up being a carnival that the town of Sharon would never forget. Everything at the carnival was proceeding as usual until the fortuneteller, Lena Miller, became severely ill. She had developed severe pneumonia and seemed to be getting worse by the day. Lena was married to Frank Miller, the head of the gypsy tribe that ran the carnival. She was also the daughter of the king of the gypsies in America, Louis Mitchell. By May 10, thirty-two-year-old Lena was dead.

Soon, thousands of gypsies converged on the area. Sample Funeral Home laid out the gypsy princess in one of the large tents at the fairgrounds. Her body was decorated with colorful silk robes and jewels. A feast was held on the site for her family and relatives. Her body remained in the tent until May 13. Over one thousand gypsies attended the funeral service. She was to be buried at Oakwood Cemetery, a short distance away. The funeral procession was so long that it took thirty minutes to pass. It was led by an Orthodox priest and the carnival band.

Over five thousand gypsies gathered at the cemetery in Hermitage. When the gypsy princess's casket was lowered into the ground, visitors passed by and tossed coins onto the lid. The grave was marked with a simple sandstone obelisk, engraved with only her name and birth and death dates. The gypsy king paid the $360 funeral bill with gold coins. For many years after, gypsies would pass by to visit Lena's gravesite. The unusual funeral was not soon forgotten in the Shenango Valley, and the story was passed down to younger generations by those who witnessed it.

THE GIANT SNAKES OF THE BROAD TOP MOUNTAINS

Since 1927, there have been reports of giant snakes in the Broad Top Mountains in Bedford and Huntingdon Counties. Most witnesses have described the snakes as

about twenty feet long, but some have claimed to have seen snakes as long as forty feet. They are usually described as gray in color, with white or yellow markings on their heads. Very large tan-colored snakes have also been sighted. The snakes have usually been spotted crossing roads, clearings and other open spaces where they would be easily noticed. At least one hunter claimed to have watched a giant snake feeding on a deer. The region is heavily forested and riddled with abandoned mines. It has been suggested that the mines may be the serpents' homes. The most recent sighting occurred in July 2000, when three men in a truck spotted a snake that was at least seventeen feet long crossing Enid Mountain Road.

THE WOMAN IN BLACK

For several weeks at the end of 1886 and the beginning of 1887, residents of the Lackawanna and Wyoming Valleys were terrorized by a strange specter known only as the woman in black. Towns throughout the coal-producing region reported sightings of the mysterious dark figure. The first encounter happened in the Pine Brook section of Scranton, where the woman supposedly attacked some girls who were walking home from a ball. In the nights that followed, the woman was seen again in a variety of locations around town and could apparently vanish at will. One evening, the specter was spotted near Lackawanna

Iron and Coal Company's mill, and some of the braver citizens decided to pursue her. The woman in black went into an abandoned mine and did not emerge.

The strange occurrences received a brief mention in the *New York Times*, and soon many surrounding communities began to report encounters with the same specter. She was seen in Carbondale and on the Depot Bridge in Pittston. The man who saw her on the bridge described her eyes as brighter than electric lights. She was seen in other suburban areas and small towns, and eventually even in Wilkes-Barre. The specter was talked about everywhere, and rumors of her appearance caused both terror and excitement. One reporter, obviously making light of the situation, claimed to have interviewed the woman in black. It did not take long before a few criminals masqueraded as the woman to commit assaults and robberies. A woman returning from a funeral was mistaken for the woman in black by two young ladies. They ran in terror until the woman caught up with them and convinced them that she was not the specter. After several weeks and a second article in the *Times* about the panic, the scare finally subsided.

A LEPRECHAUN IN PITTSBURGH

During the 1920s, a young girl living in the Uptown section of the city of Pittsburgh supposedly had an encounter with a strange little man. Her large Irish-American family lived in a small house on Watson Street. She had four

sisters and a brother, and she shared a bedroom with three of those sisters in their crowded house. One afternoon, while cleaning her bedroom, the girl pushed her bed to a different spot to sweep beneath it. She claimed that when she went to push it back, a little man in a green suit appeared on the other side of the bed. He pushed the bed in the opposite direction, away from its original location. The girl tried to return the bed to its proper place several times, but the leprechaun always moved it away. Eventually, the girl gave up and left the bed in its new position. The little man disappeared.

When the girl's father came in later to check on her, he asked why the bed was in a different spot. She told him the

story. He dismissed it as an imaginative excuse for moving the bed and allowed her to leave it where it was. Later that night, when all of the girls were sleeping, part of the ceiling collapsed. Luckily no one was hurt because the debris fell in the spot where the young girl's bed had originally been, before it was moved by the leprechaun.

A TRAIN ROBBERY

On the morning of October 11, 1924, a Cambria and Indiana Railroad train slowed down outside of Belsano, Cambria County, to pick up a passenger. As the engineer applied the brakes, a car with four men pulled up near the train and pointed guns at him. Two other men, who were already onboard the train, made their way back to a rear compartment. The robbers' target was a safe belonging to the Ebensburg Coal Company. It contained the $33,054 payroll of the Colver mine's employees. The thieves shot and killed one of the guards and took the safe. They escaped with the help of their friends in the car. Only two of the men involved, Michelo Bassi and Anthony Pezzi, were ever caught. They were found in Indiana, each with $3,000 in cash. They were later convicted and executed. The safe, the rest of the money and the other men were never found.

GIANTS VISITED PHILADELPHIA

On the afternoon of January 27, 1887, three giants took a walk down Chestnut Street in Philadelphia, attracting a considerable amount of attention. The three were brothers from Iowa who were stopping in the city for a day with their cousin before going on to an exhibition in Rhode Island. Samuel, William and Charles Robinson, ages twenty-five, twenty-two and nineteen, respectively, were all over seven feet tall. Samuel and Charles were both seven feet, eleven inches. By the time the brothers reached the corner of Ninth Street and Chestnut, they had attracted a crowd of almost three thousand curious spectators. The trio was followed by crowds even when the brothers ducked into stores and buildings. They were finally left alone when they boarded a train headed out of town.

CIRCUS TENT COLLAPSED IN UNIONTOWN

A woman was killed and hundreds of others were injured when a fierce windstorm struck the circus grounds of the Barnum & Bailey Circus on June 2, 1917. The circus was set up in Uniontown and attracted people from throughout Fayette and surrounding counties. At about 5:30 p.m., just before the late afternoon show began, a tremendous gust of wind that was described as a miniature tornado collapsed the main tent. The crowd panicked. Several people were

struck by tent poles and flying debris. Others were crushed under the collapsing seats. Elephants in a nearby tent heard the screaming and began to stampede. A thirty-two-year-old woman died of shock. Thirty of the wounded needed to be taken to the Uniontown hospital immediately, and six were in critical condition. The circus suffered $35,000 worth of damage to its property.

POWWOW AND HEX

The practice of powwowing, also known as *brauche*, has a long history among German immigrants and their descendants in Pennsylvania. It is not known how the word *powwow*, which is usually applied to American Indian rituals, came to be associated with the magical-religious practices of the Pennsylvania Dutch. The practice is a combination of ritual healing and folk magic, with Christian overtones. The powwower is not usually viewed as a menacing sorcerer or witch, but rather as a conduit for God's healing power. The primary purpose of powwowing has traditionally been to provide cures, healing and protection from curses (hexes) and other forms of evil; to locate lost objects, animals and people; and to provide good luck or blessings. This occurs through the use of amulets, incantations, prayers, charms and other rituals. Though anyone can learn the practice of powwowing, certain practitioners are considered more adept and begin learning the art at a very young age.

Powwowers usually pass down their craft through their descendants, alternating between males and females in each generation.

Powwowers have used several different grimoires over the years, but none has been as popular as the book compiled by John George Hohman in 1819 titled *Der Lang Verborgene Schatz und Haus Freund*. It is more commonly known by its English title, *The Long-Lost Friend*. The book is a collection of rituals, spells and charms for the powwower to utilize. The volume also promises to protect the bearer from harm, both spiritual and physical.

While most powwowers were perceived (and still are by some today) as benevolent healers, there were those who practiced a darker form of *brauche* known as *hexerei*. Whether as a result of payment or out of spite, the "hex doctors," or witches, would place hexes on people and animals. They would use their abilities to malevolently influence people and events. The grimoire that was most associated with this form of black magic was *The Sixth and Seventh Books of Moses.* Allegedly authored by Moses himself, the central part of the text contains prints of woodcuts of amulets, conjurations and talismans that were said to have been copied from ancient sources. Other sources were supposedly added to the text from the Kabala and the infamous Dr. Faust himself. The book acquired its dark reputation because of its section on conjuring spirits.

Though powwowing was once commonplace and practiced in the open, since the late 1920s, it has moved

underground. A combination of sensational newspaper accounts, the hex murder trial (covered later in this book) and new laws regarding the practice of medicine drove powwowing from the public eye.

MAN DENIED THAT HE WAS DEAD

Hamilton Disston had a small problem at the end of March 1887. Apparently, everyone believed that he was dead. Rumors had circulated in Philadelphia that he had been hit by a train along the Pennsylvania Railroad at the Germantown Junction. The story had spread so quickly that family and friends were shocked when they saw him walking around. Hamilton convinced local newspapers that he was still alive, and they assured the public in print that he was, in fact, still living. He had no idea how the rumors got started.

THE OGUA

The ogua was said to be an amphibious or alligator-like creature that inhabited the banks of the Monongahela River in the 1700s and early 1800s. According to the folklore of local Indians and some early settlers, the ogua reached up to twenty feet in length and weighed as much as five hundred pounds. The creatures supposedly spent most

of their time in the water but would occasionally venture onto land at night to catch deer that would come to the river to drink. The ogua would grapple the deer with its tail and drag it into the water to drown before devouring it. There were several unverified reports of settlers killing some of the creatures. It is now believed that the story may have been a cautionary tale, much like an urban legend, to prevent young children from playing too close to the river.

FIRE AT THE CANDY FACTORY

A fire destroyed one of Philadelphia's largest candy factories on January 25, 1880. Stephen F. Whitman & Sons confectionary at Twelfth and Market Streets caught fire sometime in the afternoon. The cause could not be determined. The third and fourth floors were completely burned out, and the roof collapsed through the building. The water used to extinguish the fire destroyed the candy-making machinery in the basement. The building itself suffered $5,000 worth of damage, and the company lost $65,000 worth of stock. That is a lot of melted chocolate.

Another candy factory fire occurred in Saxton on December 6, 1924. It started in the afternoon on the second floor of the factory owned by James and John Morritz. Firemen said that the vats of sugar and molasses helped to feed the fire. In less than an hour, the entire

building was in ruins. Approximately $8,000 worth of holiday orders were destroyed.

THE LIZARD MAN

In February 1981, five boys playing in a railroad yard in Arnold, Pennsylvania, were being observed by a rather strange spectator. The boys stopped when they noticed that a small, green, hairless humanoid was watching them. It seemed to resemble some sort of lizard man. The boys tried to grab the creature, hoping to capture it. After emitting a loud squeal, the lizard man squirmed free. It then fled down a drainpipe and was not seen again.

HOODOO MADE A MAN SIGN LEGAL DOCUMENTS

A rather bizarre complaint was filed with police in Scranton in August 1883. A man by the name of Hogan accused Foster Rankin, Dennis Sullivan, Edward Horan and Albert Hodge of conspiracy and necromancy. Hogan claimed that he had met the men at the Mansion House several nights before and shared several glasses of wine with them. As the evening progressed, the men introduced him to a "hoodoo" doctor, who claimed to have supernatural abilities. The hoodoo man quickly performed some type of ritual and

passed his hand over Hogan's head. Hogan claimed that the magical act caused him to believe that he was a judge of Lackawanna County, and he began to sign documents in his perceived legal capacity.

One of the documents apparently relinquished all of his property to his former wife. Another was a biography of himself, in which he admitted to committing murder, arson and a variety of other crimes. Hogan claimed to have no control over his actions while the hoodoo doctor watched over him. When he was released from their control, Hogan claimed that the men demanded that he give them ten dollars or they would publish the biography.

THE LOST CAVE OF SILVER

According to an early settler, somewhere to the west of Tionesta, in what is today the Allegheny National Forest, is a hidden cave full of veins of silver. The settler, whose last name was Hill, accidentally discovered the precious metal when he took shelter in the cave for the night. The silver was everywhere—in the walls, ceiling and floor of the cave. The next day, Hill went home, but when he attempted to find the cave again, he was unsuccessful. Another account of the silver cave came from a man who frequently traded with the Indians who lived nearby. He noticed that they had large amounts of silver and asked them where they had acquired it. The Indians blindfolded him and took him to the cave. He described it the same way as Hill. He, too, was unable to relocate the cave.

PENNSYLVANIA'S EARLIEST TORNADO

The first tornado ever to be recorded in Pennsylvania occurred in August 1724. It struck near Valley Forge and traveled through Chester and Bucks Counties. Along the way, it uprooted trees, damaged a mill, knocked down barns and blew the roofs off houses. Heavy objects like plows and millstones were tossed around as if they weighed nothing. The twister was reported in the Philadelphia paper the *American Mercury*.

THE WITCH OF FARRANDSVILLE

Homer Rosenberger recorded the following account of a witch in an issue of *Keystone Folklore Quarterly* in the 1960s. In the 1890s, the area around Farrandsville, Clinton County, was known for its logging industry. Along one of the many old logging roads lived a woman in her eighties named Sal Kervine. Kervine, who lived alone, was thought to be a practitioner of witchcraft. She was known for being easily offended and holding grudges. Many people in the nearby communities had accused her of bewitching them over the years.

On one side of Kervine's house was a very clean and clear spring. Many of the teamsters who transported logs from the forest to the railroad would stop at the stream for a drink or to water their horses. Sometimes the teamsters made Kervine angry, and when they would try to leave, their wagons would mysteriously not move. No matter how hard the horses pulled, it was as if the wagons were fastened to the ground. The men were then late for their deliveries. After several such encounters, many of the teamsters stopped going to the stream.

One day, a teamster named Tom Stewart was in a hurry. He needed to make three deliveries on the very hot day and was already running late. After the second trip, he was incredibly thirsty, so he decided to stop at the stream. Stewart had been in an argument with Kervine several months before but assumed that the incident had been

forgotten. When he tried to move his wagon to leave, he found himself facing the same difficulty that the other teamsters had faced. After several attempts to move the wagon by brute force, he realized what was happening. Stewart grabbed his axe and got off the wagon. He walked up to the front wheel and broke one of the spokes with one swing. After that, the wagon moved freely.

Out of curiosity, Stewart stopped by the stream the next day to see Kervine. She was not out walking around as usual, so he decided to peek in the window. Stewart could plainly see that Kervine had a broken arm. After that, no wagons were detained at the stream.

A Mysterious Light in the Beaver River

Sometime during the 1920s, a mysterious light was seen shining beneath the water of the Beaver River near Newport, Lawrence County. The light could be seen just to the north of the Erie Railroad Bridge. As word of the strange light spread, it attracted a substantial amount of

attention from the surrounding towns. The source of the light was unknown, and its nature could not be determined by looking at it from the railroad bridge or the riverbank.

Some spectators decided to bring rifles to attempt to shoot out the light. They were unsuccessful, but others kept trying. Eventually, the railroad police were brought in to keep spectators away from the bridge and to prevent them from accidentally shooting one another. At one point, the police had to arrest more than ten armed men who were trying to extinguish the light. After that, all of the curious were kept at a distance. It is unclear what became of the mystery light.

AN ELEVATOR ACCIDENT

A terrible tragedy occurred in the Donnelly Building in Pittsburgh on May 23, 1923. A malfunction caused the building's elevator to plunge six stories, killing four of the seventeen passengers and injuring the rest. The building was located at 1026 Fifth Avenue, and the fifth and sixth floors were occupied by the Pennsylvania Electric Mechanical Institute.

On that particular evening, the students and staff had cleared the floors and were holding a ball for over seven hundred people. About 10:00 p.m., seventeen guests boarded the elevator on the first floor and rode it to the sixth. Just as the elevator reached the sixth floor, there was a

loud crash, and the car rapidly plunged to the ground. Two large weights had broken loose and came crashing down through the car after it had slammed into the ground.

The crash caused panic at the ball upstairs. Several people almost fell into the empty elevator shaft. Dozens fainted in the ballroom. The police and fire departments arrived quickly, but it was too late for four of the passengers. Their remains were almost unidentifiable because of the trauma they had suffered.

THE EXPLODING SNAKE

A bizarre snake story was reported out of Franklin County in the fall of 1899. Frank Smith was working at the McDowell stone quarry when he stumbled across a lethargic and swollen rattlesnake. Smith found a club and returned to dispose of the deadly reptile. He struck the rattler with the club, and as he did, there was an explosion. Smith was thrown several feet away and lay unconscious for several minutes until his fellow quarry workers revived him. Aside from bruising, Smith had no severe injuries. His co-workers began investigating the strange incident and discovered that one small stick of dynamite was missing. Apparently, the snake had swallowed the stick, and it detonated when it was struck with the club.

A PTERODACTYL IN PENNSYLVANIA?

A couple driving on a mountain road in Perry County in 1981 claimed to have encountered something that was millions of years out of place. As they came around a bend, two very large birdlike creatures were sitting in the road at a distance. Their wings were the same width as the fifteen-foot highway. Their three-foot-long bodies were capped with long, thin necks and T-shaped heads. Both creatures had long, narrow beaks, and neither had feathers. The couple in the car immediately thought that they looked like prehistoric pterodactyls. Both creatures began to run straight toward the car and then took off, missing the vehicle

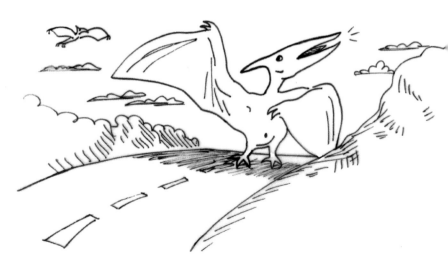

by about six feet. The couple watched the creatures quickly glide around the mountain and disappear.

POWDER MILL EXPLOSION

A series of tremendous explosions tore apart the Mosaic Powder Company in Wilkes-Barre on April 13, 1892. The first blast was in the drying mill, and seconds later the storage building exploded. The shockwave created by the explosive powder was felt forty miles away. No piece of the buildings survived that was more than a foot in length. Nearby rail cars were described as being torn and twisted like paper. The entire site was destroyed. Nine men were killed by the blast, seven of them instantly. One body was thrown 150 feet in the air. Others were found over 200 feet away.

A NEAR-DEATH EXPERIENCE

Ezechiel Sangmeister was a Pennsylvania German who for some time was a member of Johann Conrad Beissel's Ephrata Cloister in Lancaster during the mid-1700s. Sangmeister was a spiritual man who was drawn to the semi-monastic community because of its simple and pious structure. He kept a journal that told of his life experiences, religious influences and his time at the cloister. One

interesting account in his journal describes an event that occurred when he was about eight years old and still living in Germany. He describes what we now know as a near-death experience. It happened shortly after his father died, while he himself was very ill.

Sangmeister felt that he was going to die and asked for communion from the local preacher, who attempted to convince him otherwise. The boy said that he felt his father pulling at him. The next day, about noon, as Sangmeister lay in bed, he looked out his window to see the sky. He described what happened next in his journal: "It seemed as though I came out of myself. Two angels came to me, took me between them, and led me to a small door at heaven, but they said to me that I could not come in yet." Then he suddenly awoke and began yelling that he was dying. He said that he felt both fear and joy as he jumped from the bed. After the occurrence, he got better quickly and went on to apprentice as a carpenter.

The Legend of the Eternal Hunter

For well over a century, a story has circulated in Lebanon County of a phantom hunter who roams the woods and wild lands on cold winter nights. He is accompanied by a pack of ghostly hunting dogs, forever pursuing his prey. If someone is foolish enough to venture out while he is on the hunt and cross his path, he or she will be torn to

pieces by the dogs or dragged off by the hunter and never seen again.

A more benign version of the story is told in Schuylkill County. In that version, the hunter lived in a German settlement that was suffering from a bad harvest. Food stores were used up, and the community's hunters had no luck. By October, the situation was desperate. The man who became the eternal hunter was unmarried and only had his pack of hunting dogs. Since he was a skilled hunter, he promised those who remained in the town that he would not return until he found enough game to feed the village. He never returned, of course, and the settlement was abandoned. However, the hunter was unwilling to break his promise to the villagers, so his ghost and dogs still wander in the night on an eternal hunt.

THE WEREWOLF OF THE SHENANGO VALLEY

From 1972 to 1998, reports of a strange creature circulated in the Shenango Valley of northwestern Pennsylvania. Several witnesses claimed to have seen a black-haired werewolf with a short snout-like nose, jagged teeth and abnormally large round eyes. It reportedly had joints on its arms and legs that were like a canine's rather than a human's. Described as being extremely fast, the werewolf could run on both two and four legs.

"The Fresh-Carmel Boy Banished"

That was the headline in the *Pittsburgh Chronicle Telegraph* on April 6, 1890. The Pennsylvania Railroad decided to prevent young men from selling fruit, candy or other novelties onboard trains so as not to annoy passengers. Only company agents would sell newspapers and periodicals on the trains. No fruit was permitted to be taken into any of the cars. Once again, the railroads protected the best interest of their passengers by keeping them safe from dangerous fresh fruit.

The Storm Hag of Lake Erie

Lake Erie, like the other Great Lakes, is known for its sudden and treacherous storms. The numerous sunken ships that rest on the bottom are a reminder of the lake's sometimes dangerous conditions. Around Presque Isle, a local legend passed down by sailors attributes some of the danger to a supernatural source. In the waters off the peninsula dwells the Storm Hag. The hideous hag has pale green skin and yellow eyes. She has pointed green teeth and long claw-like nails that paralyze her victims when they sink into flesh. Those who have escaped the hag's clutches say that they heard a strange song before she attacked:

> *Come into the water love,*
> *Dance beneath the waves,*

Where dwell the bones of sailor lads,
Inside my saffron caves.

When the song finishes, the hag calls up massive waves and storms, grabs her victim from the ship or shore and drags him into the lake. If the storm is powerful enough, she will bring an entire ship full of sailors to their doom.

A DEADLY HAILSTORM

On the afternoon of July 8, 1853, a massive hailstorm struck part of the city of Erie. It occurred between 5:00 and 6:00 p.m. That day, the winds changed directions several times. When they came in from the northeast in late afternoon, they brought with them strong thunderstorms. The storms dumped large amounts of hail throughout the city. In some sections, large chunks of ice fell, causing considerable damage. Some hailstones measured at a dry dock were as large as seven inches in circumference. In other places, the already melting hailstones were weighed at two pounds.

Strong winds also caused damage. A saloon being constructed on Forty-third Street between Fifth and Sixth Avenues collapsed. Besides the workers, many people had entered the partially completed building to seek shelter from the giant hail. Eight people were killed in that building alone. Several other buildings had to be demolished as a

result of the storm, and several other people were killed or severely injured throughout the city.

JOHN MEYER–WITCH KILLER!

John Meyer lived near the area of West Spring Creek in Warren County in the early 1800s. Until his death in 1821, he was well known in the region as a witch killer. His method for eliminating witches was rather unique and was a variation of the methods used by powwowers in the eastern part of the state. When a bewitched person hired him to put an end to her problem, Meyer tacked a piece of paper to his wall. Then he lit a candle and had the bewitched person stand near it so that her silhouette appeared on the paper in shadow. He carefully cut out the silhouette and pinned it to a thick piece of pine wood. Meyer then loaded a silver bullet into his gun (using as little gunpowder as possible so he could recover the bullet) and fired through the paper. The spell was then broken, and the witch would die. Of course, he was paid well for such important work.

FIRE IN PHILADELPHIA DELAYS THEODORE ROOSEVELT

A large fire broke out at the lumberyard of the R.A. and J.J. Williams Company on Second and York Streets in

Philadelphia on November 2, 1908. The enormous blaze appeared to have been deliberately set and destroyed over $250,000 worth of fine hardwoods. Several firemen were trapped in the heart of the fire. When they were surrounded by a wall of flames, their engine exploded. The men were forced to run through the wall of fire to escape, and they suffered severe burns.

Part of the Pennsylvania Railroad's tracks ran across the lumberyard. The fire spread to the tracks and caused warping of the metal and burned the wood. Trains were forced to take a long detour. One train that was delayed was carrying President Theodore Roosevelt. He was on his way to Oyster Bay to vote.

SWINDLED BY MEDIUMS

In February 1890, Paul Hill of Lathrop accused two of his neighbors of swindling him out of $2,700. His neighbors, Mr. and Mrs. Brown, were spiritualists, and Mrs. Brown claimed to be a medium. Hill frequently attended séances in the Browns' home and came to believe in her powers. Eventually, Mrs. Brown claimed to have received messages from Hill's deceased parents, as well as from Jesus. They all recommended that Hill give the Browns small amounts of money when he could so that the spiritualists could use it for "holy" causes. After giving the couple money totaling the previously mentioned amount, Hill realized that he was

being taken advantage of. He brought the matter to the authorities, and the Browns were arrested.

THE GOAT MAN OF LANCASTER

One truly bizarre creature was supposedly sighted by two farmers in Lancaster County in 1973. The farmers, who were also brothers, were in one of their fields with a team of horses when they stumbled on the beast. They described it as being as large as a cow, but it ran on two long legs. Its color was gray, and it had a white mane, long fangs and even longer claws. On top of its head were two curved

horns, like a goat. The beast moved toward the horses and startled them. The brothers were thrown to the ground but managed to get up and away.

The next day, the brothers told some of the other local farmers what they had encountered. They discovered that two others in the community had also seen the goat man. One farmer was attacked by the creature but managed to grab his scythe to defend himself. The goat man snatched the scythe from the farmer's hands and bit the handle in half while he fled. A woman reportedly saw the goat man in her yard going after the animals. When she startled it, the creature threw down a dead goose and fled into the woods.

FLYING JACK-O'-LANTERNS IN RACCOON TOWNSHIP

The *Beaver Argus* reported a strange incident that occurred at the Zion Church in Raccoon Township, Beaver County, on the evening of December 21, 1876. Services had just ended, and much of the congregation was standing outside the church. To the northwest, they noticed close to fifty bright jack-o'-lantern lights (another term for will-o'-the-wisps or spooklights) rise up and dance across the sky in front of the church. The lights were described as being larger than the size of a man's fist. Each one had a two- to three-foot-long streamer of fire behind it, and they all emitted sparks. The others seemed to quickly follow the lead fireball before they all began to fade and

disappear from sight. The strange lights caused panic among some of the almost one hundred witnesses, who thought that it may have been a sign from God.

DEATH OF PITTSBURGH DOG MADE *New York Times*

One Pittsburgh show dog was so famous that an article concerning his death was featured in the *New York Times*. Count Noble, a $10,000 Irish setter, passed away on January 21, 1891. He was owned by B.F. Wilson, who lived in Pittsburgh's affluent suburb of Sewickley. The article even mentioned the dog's next of kin, as would a human obituary. Count Noble was born in 1879 to Nora and Count Windom. His children included other famous show dogs such as Gath, King Noble, Roderigo, Katie Noble, Sam Roy, Prince Noble Jr. and Roger. Wilson described Count Noble as "brave as a lion and gentle as a lamb." He also stated that the dog "understood the English Language thoroughly." The obituary went on to list the numerous awards that the dog had won at various shows.

ALBAWITCHES

Tales of the albawitches originate with the Susquehannock Indians who once lived in central and eastern parts of the state. Their legends describe short and hairy humanoids that

inhabited remote areas. European settlers also claimed to have had contact with the strange creatures. Stories of encounters with the albawitches most frequently occur around Chickie's Rock Park in Lancaster County. Their name is thought to be a corruption of "apple snitch" because they were frequently seen sitting in apple trees and eating the fruit. Though reports of this legendary humanoid are not as common as they once were, there are still occasional sightings.

ARMY PLANE EXPLODES OVER MIDDLETOWN

Two army aviators were tragically killed during a routine flight near the Susquehanna River on November 3, 1933. First Lieutenant Lloyd E. Hunting and Staff Sergeant John J. Cunningham were on their way back to Langley Field. News reports at the time did not identify the type of aircraft they were flying. A few minutes after takeoff, witnesses reported seeing a bright flash and hearing a loud explosion. The burning wreckage of the plane plunged down to a hillside above the river. Both men were killed instantly. It took ninety minutes to reach the wreckage on the heavily wooded hillside.

A STEEL PRODUCTION RECORD

In the month of September 1944, a rolling crew headed by Lawrence Murphy, Oscar Jernstron and Walter Forsbert

turned out a world record forty-two thousand net tons of steel. The feat was accomplished at the No. 18 rolling mill at the Jones & Laughlin Pittsburgh Works. The amount was 12.5 percent higher than the previous record that the same crew had set the month before. The large quantities of steel produced by the mill were vital to the war effort. The three men were personally thanked by the president of J&L, H.E. Lewis. Murphy, the oldest of the three boss rollers, learned the trade in 1900 and worked in the mill for fifty-two years before he retired.

PENNSYLVANIA'S METEORITES

Eight meteorites have been discovered in the commonwealth of Pennsylvania. Each has been given a unique name, often based on where it was found or identified. The first, called the Pittsburgh, was discovered by a farmer who picked it up to kill a snake in 1850. Realizing that it was probably made of iron, the farmer took it to nearby Pittsburgh to have it melted down. Luckily, a Yale professor managed to get a sample to preserve it.

In 1886, Allegheny County farmer George Hillman heard something hit the ground in his cornfield. He followed a hissing sound until he reached the stone meteorite that would be known as the Bradford Woods. The Mount Joy was found by Jacob Snyder in 1887 while he was digging a

hole to plant an apple tree. It turned out to be the largest found east of the Mississippi River. Railroad workers found the Bald Eagle in 1891 while constructing a roadbed. Both the Shrewsbury and the New Baltimore were discovered by farmers plowing their fields in 1907 and 1923, respectively. Both were made of iron.

The stone meteorite known as the Chicora made quite an entrance through the skies over Butler County in 1938. Dozens of witnesses saw the fireball before it slammed into the ground (and a cow). Robert Reed was lucky enough to have the Black Moshannon Park meteorite come to him in 1941. He was camping in the park when he heard a strange whistling sound. When he went outside to investigate, he found the meteorite on the ground, four feet from his sleeping son's tent.

ELOPERS TRACKED DOWN BY POLICE

Helen May Hoagland, the fourteen-year-old daughter of a Bucks County farmer, ran off with twenty-two-year-old Burroughs Wolverton on October 18, 1895. The problem was that Wolverton was already married and had two children. Farmer Hoagland, who was described as "very wealthy and heavily armed," promised to kill Wolverton when he caught him. With the help of a constable, the farmer tracked the young man to his Uncle George's house in New Jersey. The constable was barely able to prevent the farmer from killing

him. Wolverton was arrested and charged with kidnapping. The farmer's defiant daughter claimed that she was in love with Wolverton and did not care that he was married. She planned to run off with him again as soon as possible.

UNLUCKY ENGINE 1313

By March 1890, the Pennsylvania Railroad's employees decided to ask the company to stop using Engine No. 1313. It had a terrible and well-deserved reputation among the engineers and firemen who worked the trains. Over the previous year, it had been involved in more accidents than any other engine. In the summer of 1889, it plunged off a bridge near Latrobe, mangling the entire train and killing the engineer, fireman and a dozen others. A month later, the engine was repaired and back on the tracks, only to collide with another train near Manor, severely injuring the fireman. A few weeks after that, the boiler exploded while crossing the mountains, throwing the fireman from the train through a window and seriously injuring him. It was repaired again, and in January it ran into a freight train at Manor Station, destroying a dozen cars. While the engine passed Sang Hollow in early March, its oil can exploded and badly burned the engineer and fireman. After the last incident, no engineer or fireman wanted to be assigned to the engine.

SPOOKLIGHTS OF THE LACKAWANNA VALLEY

For much of the 1800s, mysterious lights would be spotted moving through the sky in the Lackawanna Valley. The phenomenon seemed to be centered on the town of Archbald, halfway between Scranton and Carbondale. Hundreds of residents of the area reported seeing the spooklights in various locations. They were spotted floating over the river, above houses, along the mountainsides and in the graveyards. They were most frequently seen emerging from the abandoned Sebastopol Mine. Some residents claimed that the lights were ghosts. They were often seen in spots where people had died tragically. In 1890, one old woman stated that she saw one close up and that it was actually a ghostly candle held by a phantom hand. Others dismissed the spooklights as will-o'-the-wisps, arising from the gases that were present in the old mines.

A DEADLY HEAT WAVE

In the first week of June 1925, the temperature in Philadelphia hovered around 100 degrees. Thousands fled the city to the seashore to escape the heat. Those who could not leave slept outside in public parks and open areas because it was cooler than indoors. In total, over 105 people died directly or indirectly from the heat.

THE LEGEND OF THE FRENCHMAN'S GOLD

There is a legend in Potter County that barrels full of French gold were buried near Coudersport. Louis de Buade de Frontenac was traveling back to Montreal after defeating the British near New Orleans in 1696. His group supposedly returned via the Mississippi, Ohio and Allegheny Rivers. When they reached present-day Potter County, they had to continue by land. The gold they had captured proved to be too cumbersome, and fearing British retaliation or Indian attack, Frontenac decided to bury it and return later. They covered the site with a large stone that had a cross carved into it. Frontenac and his men never returned for the gold, and he died in 1698. Over the years, the cross wore away and was said to be barely recognizable on the stone. The gold is said to still be buried somewhere, waiting to be found.

THE MYSTERY OF THE LENAPE STONE

The story of the Lenape Stone begins in Doylestown, Bucks County, in the spring of 1872. A farm boy named Bernard Hansell was plowing his family's field when he unearthed a strange artifact. It appeared to be about two-thirds of an Indian gorget or amulet. On one side of the stone was a variety of pictographs. On the other was something more interesting. There appeared to be a drawing of an elephant or mammoth. The gorget was the shape and style common around 1000

BC. Though it appeared old, mammoths were considered to have been extinct thousands of years before that. It was called the Lenape Stone after the Lenape or Delaware Indians, the most recent native inhabitants of the area.

Hansell supposedly held on to the stone for a while and continued to search for the other piece. Nine years later, he decided to sell it to a collector named Henry Paxton for $2.50. According to Hansell, he then returned to his field and looked even harder for the missing portion of the stone. After several months, he found it and gave it to Paxton for free. The total length of the combined pieces was four and a half inches.

The stone was immediately controversial after it was made public. Henry Mercer of the Bucks County Historical Society examined the stone in the mid-1880s but never reached any definitive conclusion, other than the fact that it could never be accurately dated. The account of its discovery was purely based on Hansell's word. Mercer did discover other Indian legends that allude to mammoth-like creatures in the northeastern and north central parts of the continent. He also noted that Hansell did not make much of a profit off the stone and implied that he was not intelligent enough to pull off such a hoax. On the other hand, none of the carvings cross over the break in the stone, which could indicate that it was carved later. And of course, there have never been any other verified mammoth carvings from that time period.

A BULL BATTLES A BEAR

An account of an interesting battle between a bull and a bear appeared in the Philadelphia paper the *North American* on Halloween 1891. A farmer in an unnamed part of the state was eating dinner one evening when he heard a disturbance among his cattle. He went out to find that a black bear had climbed over his fence to get to the herd. The farmer went to get his rifle, and when he returned, a bull had approached the bear and was attempting to

scare him off. The bull jabbed the bear once with its horns, and the bear tried to climb the fence to get away. The bull attempted to poke the bear again but was met with a swat of the bear's paw between the horns. The bull backed up and charged, and this time both animals went tumbling through the fence. After the animals staggered back to their feet, the bull charged again, but this time the bear slammed him on the top of the head and drove him to the ground. When the farmer realized that the bull was dying, he fired at the bear several times, wounding it. The bear then fled at full speed into the woods. The bull died from its injuries.

THE *Chicanere* (AKA THE BLACK DUTCH)

The *Chicanere*, also known as the Black Dutch, were German gypsies who once roamed the roads of Pennsylvania. The precise origin of the word *Chicanere* is unclear, but it was used throughout the 1800s. One suggested origin of the term is that it is the low German version of the high German word *zigeuner*, which may have been a corruption of "go away thief." Since the German population of the state was called Dutch, the German gypsies who had darker features were known as the Black Dutch.

The first bands of Black Dutch arrived by the 1750s. They came to Pennsylvania to escape the intense persecution they faced in Europe. One of their earliest meeting places was along Mill Creek in Lancaster County.

Later, favorite gathering places included Philadelphia, Reading, York, Lebanon and Pittsburgh. To support themselves financially, the gypsies practiced horse breeding and coppersmithing and made pottery and glass products. For many decades, there were two main tribes, the Einsichs and the Reinholds, as well as several smaller ones. Their exact numbers were unknown, but in the mid-1800s, the population was estimated at about three thousand.

The Black Dutch used their own dialect of Pennsylvania German, as well as their "tree language." Symbols carved onto certain types of trees could convey secret messages and warnings to other gypsies. Though they fared better than in Europe, the Black Dutch remained outsiders. When the automobile was invented, the experience of traveling between towns changed dramatically for them. Many gypsies disliked the new form of transportation because they were accustomed to horses. Some opted to settle permanently in German communities. The world wars and the industrial jobs that they created led many of the remaining gypsies to settle permanently. Only a handful remained on the road by the middle of the twentieth century.

A Tornado Strikes Elizabeth

A powerful tornado struck the town of Elizabeth on March 22, 1830. The town is located along the Monongahela River

in Allegheny County. The storm destroyed many homes and buildings and left several families with no place to stay. Fourteen houses were toppled, along with five barns, a mill and other local businesses. The tornado even destroyed a boathouse and some of the boats tied up along the dock. Luckily, there were no casualties.

THE SMALLEST OFFICIALLY DESIGNATED WILDERNESS IN AMERICA

The Allegheny River Islands Wilderness is unique for many reasons. First, it is made of seven islands in the Allegheny River that total only 368 acres. It is also the smallest officially designated wilderness area in the United States. The seven islands—Crull's Island, Thompson Island, R. Thompson Island, Courson Island, King Island, Baker Island and No Name Island—stretch from the Warren area to just south of West Hickory.

The islands have gone through many changes over the centuries. They were created over the years by deposits of sand, silt, mud and clay. In the 1700s, the Seneca Indians utilized the islands as agricultural land. They discovered that crops grew well on the rich soil, but flooding only allowed seasonal settlement. In 1779, the only Revolutionary War campaign fought in the northwestern part of the state took place in the nearby village of Buckaloons and on Thompson Island. General

Sullivan sent a contingent of men to punish the Senecas, who were aiding the British.

A tavern was established in the 1820s on Crull's Island to accommodate lumberjacks who were working in the area. It was gone by the 1850s. In the Pennsylvania oil boom of the 1860s, wells were set up on most of the islands to access the oil underneath the river. Eventually, the area reverted to wilderness and was taken over by the U.S. Forest Service.

THE McCRUTCHEON MEMORIAL

The McCrutcheon Memorial, sometimes referred to as the "spite monument," is located in Taylor Methodist Church Cemetery in Centerville, Washington County. It is called the spite monument because of a dispute that James McCrutcheon was having with his family. Rather than leave his wealth to his heirs, he spent it all on his grave marker. His two brothers were each paid $1,000 to construct the memorial, which used up the rest of his money. He died in 1902, when it was only half complete, but the brothers finished the job. The granite memorial once stood over eighty-five feet tall and loomed over the cemetery. A bad storm in 1936 toppled all but eighteen feet of the memorial.

THE HORN PAPER HOAX

According to W.F. Horn of Topeka, Kansas, the Horn Papers were a collection of historical documents gathered by his great-great-great-grandfather Jacob Horn between 1765 and 1795. They recorded the early history of southwestern Pennsylvania, southeastern Ohio, western Maryland and northern West Virginia. W.F. Horn took it upon himself to transcribe these documents in 1932. The transcriptions contained enormous amounts of historical and genealogical information that was thought to be lost. They gave the location of the lost villages of Razortown and Augusta Town, discussed numerous early families and even described the previously unheard of Battle of Flint Top, where twelve thousand Indians were massacred in 1748.

Horn sent information about his transcriptions to the *Washington Observer* and the *Waynesburg Democrat-Messenger*. Excerpts were published in the paper, and Horn quickly became a minor celebrity. Hundreds of people gathered when he came to give talks. When Horn supposedly discovered lead plates buried by the French that were marked on maps in his ancestor's papers, it seemed to verify his account, despite the fact that there were no witnesses to the discovery. The excitement surrounding the papers led to their publication by the Greene County Historical Society. Its president, A.L. Moredock, and J.L. Fulton served as editors of the three volumes. After several years of fundraising and wartime paper shortages, the books finally made it to press in 1945.

The only problem was that the papers were a hoax. They had apparently been entirely fabricated by Horn. Skeptics had appeared early on but were generally ignored because of the excitement of the "discovery." Once published, historians had access to the papers and pointed out hundreds of discrepancies and contradictions of proven historical fact. Horn had used modern phrases and the wrong calendar and wrote about the exploits of explorer Christopher Gist ten years after he is known to have died. In addition, Horn refused to produce any further evidence of the documents' authenticity. The lone document he had earlier produced was analyzed by a lab and found to be no older that 1930. Horn never disclosed to anyone why he had spent so much time and effort on such a seemingly meaningless hoax.

Attempted Train Robbery

On September 15, 1883, two men described as "tramps" boarded a Pennsylvania Railroad train in Lancaster. They climbed over the tops of the boxcars while the train was moving until they reached the brakeman and railroad policeman. The robbers drew pistols and caught the other two men off guard. When the robbers were distracted momentarily, the brakeman and police officer tackled them. One of the robbers jumped off the moving train to get away. The officer drew his pistol and shot the other robber in the torso. The wounded robber then fell backward off of

the train. The brakeman stopped as soon as he could, but neither robber could be located.

PANIC AT THE THEATRE

A terrible and unnecessary tragedy occurred at a movie theatre in Canonsburg, Washington County, on August 26, 1911. Fifteen hundred people were packed into the Canonsburg Opera House to watch the latest form of entertainment, motion pictures. Everything was fine until a small fire started in the projection room. The operator kept the door shut and managed to extinguish the fire, despite breathing damaging fumes and suffering burns on his hands. The fire was out when he walked out of the room. Some of the smoke drifted down into the seating area once the door was opened. The audience had been unaware of the fire until that time.

Someone shouted "Fire!" and the panic started. Despite the fact that there were no flames, everyone rushed to the narrow stairway that led to the door. Women and children fell to the ground and were trampled. People were screaming and climbing over piles of bodies to escape. Outside, thousands of people gathered and watched people stream out of the building, screaming in terror. When members of the fire department arrived, they were shocked. There was no active fire, only crushed bodies in the stairwell. Twenty-six people were dead, including several small children. More than sixty others had been injured after they were

stepped on. The pile of bodies at the bottom of the stairs was ten feet high.

A Destructive Lightning Strike

An intense thunderstorm pounded Ashland, Schuylkill County, on the evening of June 7, 1883. One intense lightning bolt struck a ninety-ton boulder at the top of Locust Mountain at 10:00 p.m. The immense stone shattered, and its pieces tore apart two nearby houses. The shock was said to have been felt for miles. Searchers did not find the Hungarian families that occupied the two homes until the next day. The inhabitants of the first house told them that a second lighting strike hit their house after the boulder exploded. A woman was killed and buried under the debris. Another man was paralyzed, and a boy had broken an arm and a leg. A fourth man escaped unharmed but was so traumatized that he had a mental breakdown and was found wandering in the woods by the family that inhabited the second house. The members of the second family all survived without injury.

The Philadelphia Balloon Hoax

During the late 1700s, hot air balloons were becoming objects of fascination in Europe. In September 1783, the first balloon was flown in France. In November of the same

year, the first manned flight took place. No balloons had yet been flown in the fledgling United States, but that did not stop a couple of Philadelphians from playing a prank on their friends in Paris. David Rittenhouse and Francis Hopkinson sent word to French newspapers that a man in Philadelphia named James Wilcox had flown on December 28, 1783. His flying contraption was supposedly held up by forty-seven smaller balloons, which he had to pop if he wanted to land. The story was read and believed in Paris for several weeks before finally being exposed as a hoax.

The first real balloon flight in America occurred almost ten years later, on January 9, 1793. The balloon flew fifteen miles from Philadelphia to New Jersey, taking about forty minutes to complete the trip. The balloon, which was piloted by Jean-Pierre Blanchard, received permission to fly from President George Washington himself.

DEATH BY COMIC BOOK

"Comics Blamed in Death" read a headline in the *New York Times*. In the *Pittsburgh Post Gazette*, the sensational title "Coroner's Jury Raps Lurid Killer Comics" appeared. It was September 14, 1947, and a coroner's jury in Allegheny County had just implicated comic books in the death of a twelve-year-old Sewickley boy. On August 29 of that year, the boy was found hanging from a clothesline in the family's basement. His mother told the jury that her son was "an

incessant reader of comic books and probably hanged himself re-enacting one scene." Though the jury ruled the death accidental, it cited comic books as a contributing factor. Comic books had claimed another young victim, or at least that is what many educators, parents, civic organizations and law enforcement officials believed. It was Pennsylvania's turn to lead the crusade against comic books in the postwar years.

The Allegheny County coroner, William McClelland, called on state law enforcement officials and politicians to ban comics with unacceptable themes (which was most of them). The Pennsylvania Chiefs of Police Association supported him and passed a resolution attributing the rise of crime and juvenile delinquency, in part, to comic books. Other law enforcement agencies followed suit. Similar sentiment had been expressed around the country since the end of World War II because of the increasingly graphic content and serious subject matter of the comics. It had become a moral panic. The scare faded in the mid-1950s, when many of the publishers were forced out of business or complied with the new Comics Code. (And by that time, they could blame juvenile delinquency on rock 'n' roll.)

MOLL DERRY–THE WITCH OF FAYETTE COUNTY

Moll Derry had a fearsome reputation in Fayette County and throughout much of southwestern Pennsylvania. Described

as an old hag, she was credited with an impressive array of magical abilities. She lived near Haydentown, several miles south of Uniontown. Most of the stories that have been told about her take place between the 1780s and the 1820s.

Many locals believed that Derry could cast spells, place curses, predict the future and even transform into animals and birds. There were even those who claimed that the old woman could fly. People came to her for help in finding lost money and possessions, tracking down thieves, finding missing persons and foretelling the future. Derry also sold whiskey to supplement her income. The witch was known to take vengeance on those who were foolish enough to cross her. She made cattle ill, prevented bread from rising and even caused deaths, if you believe the stories.

One of the most popular accounts tells of how Derry cursed three men who had mocked her and her abilities. She told all three men that they would hang. It was not long before the curse seemed to take effect. One of the men, John McFall, killed a man in a drunken brawl in 1795. He was quickly convicted and hanged for the murder. The second man, Ned Cassidy, proceeded to kill two men, and he was hanged five years after McFall. When the third man, whose name is not known, learned the fate of the other two, he hanged himself in Greene County.

It is not clear exactly how and when Moll Derry died. She seems to have simply disappeared. Or perhaps she turned into a bird and flew away.

LIBRARIAN SPOTTED UFO

On the sunny and clear afternoon of June 4, 1961, a librarian spotted strange objects in the sky over Blue Ridge Summit. Mrs. Annis saw a large oval-shaped object floating low in the sky just to the north. To the east, she noticed several smaller objects just above the treetops. Suddenly, at a very high rate of speed, the smaller UFOs flew toward the larger one. They all moved farther away behind another set of trees and out of Mrs. Annis's sight.

TWO CIRCUS TRAIN WRECKS

At 8:30 p.m. on October 22, 1885, the first five cars of Adam Forepaugh's eighteen-car circus train wrecked and derailed when the axle on one of the front cars snapped. The accident shut down the line for over five hours. One of the cars that overturned contained twenty-five horses. One of the horses died, and several others were injured. The accident happened at the Valley Creek switches near Woodbine. Several of the circus's attractions were destroyed, including the beehive chariot, the goddess of liberty chariot and Forepaugh's personal buggy. The wreck was Forepaugh's sixth train accident that year.

Another even more dramatic circus train accident occurred in May 1893 near Altoona. The train carrying W.L. Main's circus jumped the tracks and was severely

damaged. Six people were killed, and at least seven others were seriously injured. The cars carrying the animals were knocked open. Some of the animals were injured, and a tiger, a water buffalo, hyenas, a bear, alligators, three lions, a black panther, monkeys, birds and snakes all got loose. Forty-nine horses were killed. The elephants and camels were uninjured and did not escape.

Some of the animals were recaptured by the circus crew. Two of the three lions were subdued. The snake charmer caught one of the anacondas in the nearby bushes. The tiger had made its way to a nearby farm and decided to eat a cow. The farmer, Alfred Thomas, shot and killed the tiger before it could kill any more of his animals. The rest of the circus animals eluded capture. The financial loss for the circus was estimated at $100,000.

GOLDFISH PUT OUT PHILADELPHIA FIRE

In November 1901, a store on Germantown Avenue owned by Thomas E. Henry had a small fire. It could have been much larger if not for a conveniently placed fish tank. The fire started on furniture that happened to be in front of an aquarium large enough to hold three hundred goldfish. The heat from the fire cracked the glass, and the water spilled out and extinguished most of the fire. The rest was put out by flopping goldfish, most of which survived the ordeal.

THE EVIL WOLVES OF ELK CREEK GAP

In the late 1800s, Centre County was home to several logging companies. Because of the demand, lumber was being transported through Elk Creek Gap almost twenty-four hours a day. A story eventually circulated about why the practice was stopped. After a while, strange wolves descended from Hundsrick Mountain and began jumping onto the loaded sleds. The wolves would not attack, but the sleds could not be moved while the wolves were on them. Sometimes only one paw was required to stop the sleds. No matter how hard the drivers pushed the horses, they would not move. Eventually, the wolves would leave, after they had exhausted both the horses and the driver. Some of the drivers painted hex signs on their sleds, hoping to drive away the wolves. Nothing seemed to work. Many believed that they were actually werewolves or that they had been sent by a witch. Eventually, the drivers stopped hauling logs after sundown.

A MIRACLE IN AMBRIDGE?

On Good Friday 1989, several parishioners attending services at Holy Trinity Catholic Church in Ambridge, Beaver County, believed that they witnessed a miracle. A large wooden and plaster crucifix appeared to close its eyes. Several days later, the eyes reopened. Photographs

were taken to document the occurrence, and at first glance the images appeared to verify the miracle. The Diocese of Pittsburgh launched an investigation, interviewing over 150 witnesses and examining the photographic evidence. After a thorough investigation, it was determined that the event was most likely an optical illusion caused by the angle and lighting. Many parishioners continued to believe that the miracle was authentic.

STRANGE RAINS

Charles Fort, the first modern investigator of the unexplained, documented a few strange rains in Pennsylvania. On July 23, 1866, a strong storm struck Hobdy's Mills. The storm did not dump just rain on the region, however, but also thousands of red, inch-long lizards. Many of the lizards were alive and crawled away. In 1869, snails rained down in "a storm within a storm" in Chester County. For a while, the snails were displayed at the Philadelphia Academy of Natural Sciences. On March 2, 1892, the residents of Lancaster looked out over the fresh layer of snow to see a rain of tiny worms. Mud fell from the sky in various areas in the northern part of the state in April 1902. The sources of these rains were never determined.

EGYPTIAN MUMMIES INVADED PENNSYLVANIA

In 1833, six ancient Egyptian mummies were displayed in both Philadelphia and Pittsburgh. There was a surge of public interest in the field of Egyptology after the Napoleonic Wars in the early 1800s. Exhibits of Egyptian artifacts attracted considerable attention. Advertisements described the mummies as being over three thousand years old. They had "perfect expression," and their hair was described "as if now living." The traveling exhibit attracted thousands of curious onlookers in both cities.

WEB-SPINNING UFOS OVER DANVILLE

A man named William Hummer was pulling up to his house about two o'clock in the afternoon on May 4, 1981. As he parked his motorcycle, he noticed what he described as "cobwebs" on his roof, on his neighbors' homes and on telephone poles and trees. While observing the material, he realized that there were things moving around in the sky. It was difficult to make out details at first because of the bright sun, but he could tell that they were disc-shaped.

A few moments later a deliveryman arrived and attempted to pick up some of the white "webbing." It disintegrated in his hand. The material kept falling as the men watched. Hummer retrieved a pair of binoculars and managed to get a better look at the discs when they got

farther away from the sun. He described them as circular with a peaked dome. They traveled in groups of two or three and changed directions rapidly. When Hummer's sister arrived half an hour later, the webs were still falling from the sky and being blown around in the air. None of the webs lasted long enough to be preserved.

THE COLDEST MONTH

Pennsylvania has experienced many cold winter months over the centuries, but the coldest on record occurred in 1977. In January, the average mean temperature for the state was thirteen degrees, more than eleven degrees below normal. In some parts of the state, it was much colder. In Bradford, the temperature reached as low as twenty-five degrees below zero on January 29, with the high temperature reaching only six below. Many counties suffered through numerous days of negative temperatures.

STRANGE LITTLE MEN

On December 17, 1956, a housewife in Conashaugh went outside with a flashlight to investigate a noise. To her surprise, the beam of her flashlight fell upon two little humanlike men in what looked like silver flight suits with

helmets. They were about three or three and a half feet tall and remained motionless for several minutes while the light was on them. The woman went inside to get her husband, but when they returned, the men were gone.

BALL LIGHTNING IN PHILADELPHIA

Ball lightning is a little-understood phenomenon. It is not even accepted as a real occurrence by all scientists because of its rarity. But there was a woman who lived in south Philadelphia in 1960 who was sure that it was real. Louise Mathews had a frightening experience with ball lightning that summer. As she was resting on her couch in her living room one day, a red ball of light passed right through her front window and blinds, causing no damage to either. As it passed her, she felt tingling on the back of her neck and head. The ball sizzled and buzzed as it quickly passed into her dining room and out another window. Mrs. Matthews called her husband, who quickly came home from work. By the time he arrived, the hair had fallen out of the back of her head where she had felt the tingling. Her hand was also burned where she had felt her head.

ARROW OF FLAME

In 1909, the people who lived near Stockton reported seeing what was described as an "arrow of flame" hovering above

a certain spot on the mountain. It could be seen every night from about 9:00 p.m. to midnight. In that same area, the mutilated body of a woman had been discovered in a barrel two years before. The crime had never been solved, and her killer was still at large. Locals believed that the arrow of flame would continue to appear until her killer was brought to justice. There seems to be no record as to when the flame was last seen.

CREEPY CLOWNS IN PITTSBURGH

In 1981, Pittsburgh experienced an invasion of "evil" clowns. Reports were made of men dressed as clowns and other cartoonlike animals harassing and attempting to lure young children. The first incidents happened in June, and at the height of the sightings, the police were receiving as many as fifteen reports a day. In the first week of June, a group of children playing in the Hill District was harassed by two men dressed as clowns who had pulled up in a van. In Arlington Heights, a man in a gorilla suit and a man dressed as a clown attempted to lure a boy into a van. Some children in Garfield were stalked by a man in a pink and white rabbit suit who drove a blue van. A week later, the rascally rabbit was spotted in Allegheny Cemetery. People in several other city neighborhoods called the police to report clown sightings. No one was ever apprehended. After a few weeks, the reports ceased and the evil clown panic was over.

CURED OF FOOTBALL MANIA

At the 1908 meeting of the American Neurological Association in Philadelphia, guests heard the story of a strange case that Dr. Charles Mills and Dr. Charles Frazier encountered. Both doctors were from the University of Pennsylvania. One of their patients was a woman who suddenly became obsessed with football. She would rush from game to game and would travel as far away as New York and Boston. She started becoming rowdy and

"irresponsible" at the sporting events. She also frequently suffered from dizziness, nausea and disorientation. (I realize that this sounds like a normal weekend in football season, but we are talking about 1908.) The doctors decided to operate and discovered that the woman had a three-inch-long cyst on her brain. It was successfully removed. After the operation, she recovered quickly and was cured. It should be noted that football mania is not recognized as a disorder in Pittsburgh.

A FACTORY EXPLOSION

On May 1, 1942, an explosion tore through the Central Railway's Signal Plant in Versailles, Allegheny County. The factory was manufacturing signal flares and torpedoes for the railways, and its work was not directly war related. Most of the workers were women who had taken positions left vacant when the men entered the military. The blast happened at 2:40 p.m., while twenty women were mixing potash and sulfur for the torpedoes. Pieces of the eighty-foot-long roof were blown hundreds of feet in the air. The explosion was felt for a mile. The fire was quickly extinguished, but eight of the women were killed and eleven others were wounded. Sabotage was initially suspected, but the FBI investigated and found no evidence.

A STRANGE CREATURE IN COATESVILLE

In 1939, several farmers reported seeing a strange creature in the fields and woods near Coatesville. It was described as about two or two and a half feet tall and had a long neck and small head. The mystery creature could also jump like a deer, but it had paws instead of hooves. It was light brown with white on its sides. The animal's strangest characteristic was its scream, which was described as eerie and similar to two cats screaming at once.

AN APE SCARE IN CORRY

A four-foot-tall apelike creature was spotted in the woods just south of Corry, Erie County, on September 18, 1938. Three children in the Clabbatz family came running to their father from the woods when the ape they saw started chasing them. Their father gathered a hunting party of almost fifty men and went after the creature. They did not find it, but the next day it was spotted by two farmers on nearby land. The hunting party went out again but failed to find the ape. After a few days with no further sightings, they decided that they had scared the creature away.

THE MYSTERY OF THE *Walam Olum*

The *Walam Olum*, which translates as "Red Record" or "Red Score," is allegedly a historical account of the Lenape Indians, also known as the Delaware. Translated by Constantine Samuel Rafinesque and his contacts, it was first published in the 1830s. Rafinesque claimed that the original history was written in the form of pictographs on birch bark tablets that he acquired in the 1820s in exchange for medicine. In historical times, the Lenape homeland included much of Pennsylvania, but the story in the *Walam Olum* revealed the Lenapes' origin. It contained a creation and flood story and several accounts of migration and battle. It also contained a list of chiefs that dated back over two hundred years.

The published version contained just under three thousand words, set opposite the Lenape pictographs. Though it was initially accepted by some scholars and some members of the tribe, doubt about the work's authenticity began to appear. The Lenapes did use birch bark scrolls, but the pictographs that appear in the book do not match those that have been discovered by other archaeologists and historians. Some investigators wondered if the book was a partial hoax but based on real legends. New efforts were made to examine the original translation and the sources used by Rafinesque. It was discovered that parts of his translation were in reverse, and he was trying to find Lenape words to best

match English ones. Also, many of the pictographs bore resemblances to similar writings from other ancient peoples that were available at the time of translation. By the end of the twentieth century, most scholars, as well as one branch of the tribe that had previously accepted the book, concluded that the *Walam Olum* was a hoax and did not represent an authentic tradition.

THE LEGEND OF THE THUNDERBIRD

The legend of the thunderbird was part of American Indian mythology long before the arrival of European settlers. Variations of the legend existed in many tribes. The Indians often assigned animal traits to nature in their myths. Most modern anthropologists and folklorists believe that the idea of a giant bird that created a roaring or rumbling noise by flapping its immense wings was just a way to explain or symbolize thunder.

But there are those who claim to have actually seen this giant bird, and many of the sightings have come from Pennsylvania. Two hotbeds of thunderbird sightings have been the Black Forest region and, more recently, western Pennsylvania. The birds have been described as black or very dark brown in color. They are usually said to resemble a vulture or eagle, except much bigger and with very large beaks. In the Black Forest, some sightings occurred as early as the 1880s. In 1922, at

Hammersley Fork, Hiram Crammer witnessed the flight of a thunderbird that allegedly had the unbelievable wingspan of thirty-five feet. Near the same area in 1964, several construction workers insisted that they saw one of these large birds carry off a fawn.

Pennsylvania writer Robert Lyman saw one of the birds in the early 1940s near Coudersport. He estimated its wingspan to be about twenty feet and described it as vulture-like. It was brown in color with a short neck and "narrow wings." In 1969, the wife of the sheriff of Clinton County saw an enormous gray bird land in the middle of Little Pine Creek. The bird's wingspan was as wide as the creek bed, which would have made it almost seventy-five feet. After a few moments, it lifted off and flew away.

In western Pennsylvania, there have been quite a few sightings since the 1990s. In May 1998, a man saw a very large black bird with a twenty- to twenty-five-foot wingspan flying over the Ohio River in Allegheny County. During the 1990s, there were also reports of a thunderbird seeking shelter in the Wabash Tunnel. In the following years, more sightings were reported in the town of Greenville and in Westmoreland County.

GEORGE WASHINGTON'S GRISTMILL

George Washington made several dangerous trips to western Pennsylvania in his youth as an officer in the

Virginia militia. He participated in all of the major campaigns of the French and Indian War that took place in the area. In fact, he fired the first shots of the war in Fayette County. Because he had previously been a land surveyor, he recognized the potential value of the western lands as he passed through. In 1769, he sent his friend Captain William Crawford to survey and purchase land in present-day Fayette and Washington Counties. In total, he bought more than sixteen hundred acres.

Part of the land he purchased was near the modern town of Perryopolis, Fayette County. It was situated near a stream, now known as Washington's Run, and was the perfect place for a gristmill. Since Washington lived in Virginia, he hired a man named Gilbert Simpson to oversee the property and handle the construction of the mill. It was one of the first located west of the Appalachians. Work began in 1774 and was completed in 1776. The mill began operating immediately, but it was soon shut down for a few years because of the Revolution.

When Washington visited the mill in 1784, he found it in bad condition. He ordered some repairs to make the mill functional again. Thinking that Simpson was mismanaging his property, Washington decided to lease the land and mill. No one was interested. In 1789, the mill and surrounding land were finally leased, and then sold, to Colonel Israel Shreve. Washington had trouble getting timely payments from Shreve. Ultimately, he made almost no money from the mill or property.

The mill passed through several owners until 1936, when it was destroyed in a windstorm. The ruins and foundation were the subjects of a historical and architectural survey in 1968, but nothing came of it. In 1989, the Perryopolis Area Heritage Society took over the property, raised funds and reconstructed the gristmill, which opened to the public in 1999.

BELSNICKEL

Belsnickel is a German Santa Claus–like character whose tradition was brought to Pennsylvania by immigrants. Translated, the term means "Nicholas in furs." Belsnickel became part of the Pennsylvania German Christmas celebration, but he was scarier than the modern image of Santa Claus. When he visited on St. Nicholas Day (December 6), he carried a bag of candy and nuts but also coal, a stick or branches and sometimes a small whip. The treats were for the good boys and girls, while the bad children could expect coal and a lashing from the sticks or whip as a reminder to behave.

There are many variations of the tradition in German communities throughout the state. It also became a tradition for young people to dress in a mask or Belsnickel costume to go door to door singing in exchange for candy or coins. The tradition declined in the 1920s as the more commercialized version of Santa Claus became dominant.

UFO OVER WILKES-BARRE

Joseph Greiner, an experienced radio operator, air traffic controller and weather observer, witnessed an unusual object in the sky above Wilkes-Barre on July 8, 1952. He spotted the object about 10:00 p.m. and described it as green with a reddish dome on the top. It streaked across the sky above his head at a speed he estimated to be one thousand miles per hour. The object only remained in view for about ten seconds.

THE ORIGIN OF THE JEEP

The original Jeep was designed and constructed by the American Bantam Car Company in Butler County. Bantam designed the vehicle when the federal government put out a call for a forty-horsepower vehicle that could haul a quarter ton but weighed less than thirteen hundred pounds. World War II loomed on the horizon, and the U.S. military wanted to be prepared. The small Bantam Company took less than two months to deliver a prototype to the government. It was tested by the army in Maryland in September 1940. The Jeep passed every grueling test it was put through, and the government ordered fifteen hundred more.

During the testing stage, two of Bantam's competitors, Ford and Willys, got a look at both the blueprints and design. Willys submitted a similar vehicle and was ultimately awarded the

contract because it had a much higher production capacity. In total, only two thousand Jeeps were made by Bantam, but it is still credited with the innovative design.

PENNSYLVANIA'S PETROGLYPHS

Petroglyphs are a form of writing or art carved into rock in ancient or pre-modern times. The Indians in Pennsylvania left many examples of petroglyphs carved into stones and boulders throughout the state. They are usually located around rivers and represent nature, humans, supernatural entities, animals, the moon, the sun and stars. The drawings in this state tend to have stylistic similarities to other Algonquin art that has survived. Some researchers have hypothesized that the petroglyphs may have represented boundary markers and/or sacred sites. They may have also served as teaching tools or to mark astronomical phenomena. Since they cannot be dated or directly translated, it cannot be known precisely what they signify.

There are almost forty petroglyph sites that have been officially recorded in the state. They are in two primary groupings. One batch of almost thirty sites exists along the tributaries of the Ohio River. They include Indian God Rock and the Parkers Landing Petroglyph along the Allegheny River. Indian God Rock has carvings that represent the supernatural and images that are half man, half animal.

The second batch is located along the Susquehanna River and consists of ten sites with over one thousand individual carvings. Many of the carvings consist of symbolic designs, human hybrids, astronomical representations and animal tracks. Some of the petroglyphs at Safe Harbor were removed for preservation in the 1930s because the site was flooded for a dam.

A UFO WITH A STRANGE FLIGHT PATTERN

At one o'clock in the morning on February 9, 1957, Roger Standeven looked at the night sky over Philadelphia and saw a strange object moving in an even stranger pattern. Standeven saw a white UFO with a red light "falling like a leaf." The object then stopped, shot back up into the sky and quietly fell again. It repeated the pattern over and over, each time going higher in the sky. Eventually, Standeven could no longer see the object.

MAN SHOT PANTHER THAT WAS NOT SUPPOSED TO EXIST

The eastern panther has officially been extinct in Pennsylvania since 1874, though several were said to have been shot in 1891. After a bounty was put on the animal by the state in 1807, it took less than a century to wipe out

the population. Killing one of the feared animals became a matter of pride for hunters. Over the years since their extinction, there have been many panther sightings, but none has been substantiated. There is one exception.

On October 28, 1967, John Gallant of Edinboro, Crawford County, shot a panther a mile and a half southeast of town. The panther was a young, half-grown female that weighed about forty-eight pounds. It was with another larger panther that was wounded but escaped. The wounded panther and a third panther were allegedly caught in a trap a day or two later, but they escaped again.

The dead panther attracted substantial attention from naturalists, who debated the possibility of the animal's survival after so much time. There was some speculation that the animals may have escaped from a circus performer's farm just over the border in Ohio, but no definite conclusions were reached. At least one wildlife biologist who examined the case in the 1980s thought that the panther showed some signs of domestication. Occasional panther sightings are still reported throughout Pennsylvania and neighboring states, though no new specimens have been captured.

War of the Worlds CAUSED PENNSYLVANIA PANIC

The radio dramatization of *War of the Worlds* that aired on October 30, 1938, is famous for the panic it caused around

the country and especially on the East Coast. Orson Welles and the Mercury Theatre group decided to set their version of the story in modern times as opposed to nineteenth-century England, as in the original novel. They selected the small town of Grover's Mill, New Jersey, to be the invading Martians' landing point. Part of the story was told as if it were a series of news reports, so when some listeners tuned in late, they believed that the invasion was real. The reports detailed the defeat of U.S. military forces by the Martians, as well as the arrival and movement of more of the alien invaders.

While the level of the panic was certainly exaggerated by the press, there were many cases of people, some in Pennsylvania, reacting to the broadcast as if it were real. Several students from New York and New Jersey who were studying at the University of Pennsylvania in Philadelphia packed their bags and prepared to hurry home to be with their relatives. City hall and the police were bombarded with calls from anxious people trying to determine the truth.

In Pittsburgh, a man reportedly came home to find his wife ready to drink some type of poison. She had heard the broadcast and the reports of the heat rays that were incinerating anyone in their path. She screamed, "I would rather die like this than like that!" Her husband was able to calm her down. Not far away in Uniontown, a group of women playing cards dropped to their knees and began praying like many others would before they realized the broadcast was fiction.

The Scranton area also had incidents. In the nearby town of Jessup, a dozen families grabbed their most important possessions and prepared to flee. Several men working the evening shifts at various jobs received phone calls from their wives telling them to hurry home. One man stormed into a newspaper office and demanded to know if the Army Reserves had been called out.

One Pennsylvania man was driving back toward the state from the west with his two daughters when they heard the broadcast. Both girls fainted during the fake news reports. He stopped in Ann Arbor, Michigan, to determine if the Martians were really moving into Pennsylvania.

CIRCUS TENT COLLAPSED AND BURNED

John Robinson's Circus was in Ridgeway, Elk County, on May 23, 1902. During the show, a powerful storm developed with heavy rains and strong winds. Partway into the performance, the wind collapsed the main tent and several others. As the crowd was pinned under the tent, it caught fire. A panic ensued as all the circus-goers fled from the burning tent out into the powerful storm. Luckily, the rain helped extinguish the fire. No one was killed, but almost everyone sustained minor injuries.

THE HORNED SKULL

A human skull with a pair of two-inch horns was discovered during an excavation by archaeologists in Syre, Bradford County, during the 1880s. State historian Dr. G.P. Donehoo and A.B. Skinner of the American Investigating Museum in Philadelphia were in charge of the dig. The skull was found in a burial mound with the rest of its seven-foot-long skeleton. The burial was believed to date to approximately AD 1200. The skull and skeleton were shipped back to the museum in Philadelphia for study, but shortly after their arrival, they were stolen.

A PAIR OF PATENT MEDICINES

Before the Pure Food and Drug Act of 1906, patent medicines were sold almost everywhere. The questionable concoctions claimed to cure or prevent all kinds of ailments. Often, they actually included addictive substances (like opium or cocaine) and had little real medicinal value. A pair of interesting patent medicine advertisements appeared in the *Advance Argus*, published in Greenville, Mercer County.

In 1888, an ad appeared for a medicine known as the "Electric Bitters." It stated that a purer medicine did not exist.

For only one dollar a bottle, the bitters could cure all liver and kidney disease; eliminate headaches, constipation and indigestion; and remove pimples and boils. If that were not enough, it could also cure malaria. Sounds like a good deal!

Another advertisement in 1891 presented a solution to a common problem. Apparently, rich, pretty and educated girls kept eloping with tramps, coachmen and other scoundrels. Luckily for the reader, Dr. Franklin Miles diagnosed the real problem. According to him, the girls were impulsive, hysterical, nervous, unbalanced and subject to immoderate crying and laughing because of their weak nervous systems. But Dr. Miles had the solution. The only remedy that was necessary was a bottle of his Restorative Nervine medicine. He also sold his celebrated New Heart Cure, the finest of heart tonics, for those who suffered from fluttering or shortness of breath.

MAN PERFORMED HIS OWN WEDDING CEREMONY

On June 11, 1913, Dr. Askelon Mercer performed his own marriage ceremony in Beaver County. The doctor was seventy-five years old at the time. His bride, Sarah Calgrove, was sixty-five years old. It was the sixth time that Dr. Mercer had been married. He had been licensed decades before and had performed all of his weddings himself.

FIREMAN PUT OUT HOUSE FIRE BY HIMSELF

Joe Baldauf was a fireman from New Castle who took his job very seriously. One morning in January 1925, he was taking a walk along County Line Road near an old cement works. As he passed a nearby house, he realized that there was smoke coming out of its roof. Baldauf immediately rushed into the house and alerted the people inside to the danger. Then he borrowed their axe and climbed to the roof to cut a hole to get a better look and release the smoke. He was able to determine that damage to the chimney had started the blaze.

In the meantime, the residents followed Baldauf's orders and started filling buckets of water. They managed to pass the buckets up to Baldauf so he could extinguish the fire. His quick thinking minimized the damage and prevented the fire from spreading. Everything was under control by the time more firemen arrived.

A FOLDING BED ACCIDENT

On March 3, 1909, a bizarre tragedy occurred in Pittsburgh. Charles Murray and his family had just moved into a house on Penn Avenue. They had moved in quickly, and the folding bed that the parents used was hastily assembled. It was temporarily placed on the first floor, until their bedroom was finished. Murray's daughter woke that night to muffled groans and strange noises. She

was frightened and stayed in her room for almost an hour until she decided to go to her parents. When she went downstairs, she saw that the bed was up, and the bottom halves of her parents' bodies were pushed up to the ceiling. Their upper bodies were pinned between the wall and the bed. She went for help, but her father's injuries were too severe, and he died. Most of his bones were crushed. Mrs. Murray was badly hurt but eventually recovered. Her husband's larger body took the brunt of the force and allowed her to survive.

LIVERMORE–PENNSYLVANIA'S SUNKEN TOWN

The town of Livermore once stood along the Conemaugh River in Westmoreland County. Today, what is left of the town is submerged under the reservoir behind the Conemaugh River Dam. The dam was constructed as a result of the Flood Control Acts of 1936 and 1938. The acts were passed after the great St. Patrick's Day flood submerged parts of Pittsburgh and most of the other river towns in the southwestern part of the state. Livermore was already in decline because of the impact of previous floods, and the 1936 flood sealed the town's fate. The best location for the dam would necessitate that the town be abandoned. Most but not all of the buildings and remaining structures were torn down before the area was intentionally flooded in 1952.

THE GREAT CIRCLE HUNT AT POMFRET CASTLE

Circle hunts, also known as animal drives, were common in parts of Pennsylvania until the 1830s. The hunts involved gathering as many hunters as possible and spreading them out in a large circle in the woods. The hunters would drive any game in their path toward a central clearing, where they could fire on the animals and kill many more than would have been possible on their own.

One of the largest recorded circle hunts occurred at Pomfret Castle, a French and Indian War fort, in 1760. It was led by a hunter named "Black Jack" Swartz. He organized over two hundred hunters in a circle thirty miles in diameter. The hunters made a variety of noises and fired their guns to push the wildlife toward the central clearing. When the gunfire was over, the hunters had killed 109 wolves, 112 foxes, 17 black bears, 41 panthers, 198 deer, 2 elk, 111 buffaloes, 114 bobcats and over 500 smaller animals.

Even the two hundred hunters and their families could not use all the animals. The smell of their decomposition drove settlers from their cabins up to three miles away. Eventually, some of the remains were buried to control the stench.

SOME CASES OF SPONTANEOUS
HUMAN COMBUSTION

Spontaneous combustion in humans is a phenomenon that is not accepted by all scientists. When it occurs, a person is reduced to ashes by an incredibly intense fire that starts on or in him. Usually the surrounding area suffers little damage, but the victim is incinerated. It is not known how or why this happens. Pennsylvania has a few recorded cases of the unexplainable fire.

On January 28, 1907, a case was reported in Pittsburgh. Albert Houk's wife was reduced to ashes. The area of the house that she was sitting in had no fire damage. It was as if she was consumed from the inside out.

Helen Conway of Drexel Hill suffered a similar horrible fate on November 8, 1964. Conway was a smoker, and an occasionally careless one at that. Initially, it was believed that she accidentally caught herself on fire. All that remained of her were her legs from the knees down and part of the chair she had been sitting in. Investigators took a closer look when they assembled a timeline for the fire. They realized that the entire thing happened in as little as six minutes and could not have taken longer than twenty. There was too much damage done in such a small amount of time. The true cause remains a mystery.

Two years later in Coudersport, there was another incident. A ninety-two-year-old retired doctor named John

Bentley was apparently consumed by flames. His charred walker and part of his leg were discovered in a bathroom on the first floor of his home. The fire had burned a small hole through the floor. Nothing remained of the rest of Bentley but ashes.

SAM MOHAWK MURDERED THE WIGTONS

A gruesome murder occurred in Butler County in July 1843. The entire Wigton family, except for James, the husband and father, was massacred by an Indian known as Sam Mohawk in a drunken rage. Mohawk was a Seneca originally from New York. He had been traveling south through Pennsylvania, presumably looking for work, and drinking heavily in taverns along the way.

After Mohawk became heavily intoxicated at the Stone Tavern, several bar patrons pitched in to get him a stagecoach to take him back north. He slipped out of the coach and took off into the woods. Several men chased after him. After stopping to sleep for a brief time, he woke up and stumbled onto the Wigton farm. James Wigton was helping at his father's farm and was not home. Mohawk entered the kitchen and surprised Margaret Wigton. For some unknown reason, he stabbed her. Margaret ran out of the house and into the yard, but Mohawk followed and beat her to death with a rock. Instead of running, Mohawk reentered the house and went upstairs, where

he proceeded to kill the five Wigton children, all of whom had been sleeping.

When the murder was discovered, search parties were deployed, and it wasn't long until Mohawk was in custody. He was in held in jail for six months while he awaited trial. During that time, he confessed to the crime and converted to Christianity. Mohawk himself had been married, and his son became ill and died while he was in jail.

The trial was held in December of the same year and lasted only a few days. The jury took less than an hour to deliver a guilty verdict. Mohawk was hanged in the Butler County jail yard on March 22, 1844.

The Collapse of the Boydstown Dam

The Boydstown Dam was located along Connoquenessing Creek in Butler County. Large amounts of precipitation caused problems at the dam on August 28, 1903. Originally constructed in 1897, the structure was only six years old when the top of the dam was eroded by the rushing creek. Eventually, the water pushed open a 140-foot-long hole along the top. A 30-foot wave rushed down the creek, flooding parts of the city of Butler and other nearby towns. Luckily, word had been relayed by telephone and evacuations had already begun. Some people had to be rescued by firefighters, but there was only one fatality. It happened later that day when someone attempted to swim across the swollen creek.

THE DORLAN DEVIL

Chester County had its own version of the Jersey Devil appear in the 1930s. While working to the north of Dorlan, two men sighted a jumping creature that did not resemble any animal or human. Both men had experience with local wildlife and insisted that the thing they saw was nothing identifiable. A search party was sent out, but no trace of the creature was found.

In 1937, a millworker, his wife and a female friend had a close encounter with the creature one night in July. They were driving down a road just outside Dorlan when their headlights fell on the beast. They described it as being like a giant kangaroo, with long black hair and terrifying giant red eyes. The creature jumped across the road and into the swamp in one leap. They went home and called about a dozen friends to form a search party. Again, nothing was found.

CHRISTMAS TREE SURVIVED FIRE

A fire tore through the home of George Burg in Philadelphia on New Year's Day 1952. Most of the first floor was destroyed, except for a small corner where the Christmas tree stood. Often live trees are the source of fires around the holiday season. In this case, it was the only thing to survive.

THE "QUIETEST FIRE"

The town of Bedford was having its annual Halloween Parade on the evening of October 31, 1955, when a call came into the fire station. Stanley Stroup smelled smoke in his home in Bedford Heights and was unable to locate the source. Because the parade had closed several main streets and there were people everywhere, the fire chief decided not to use the sirens. He feared that the sirens might cause panic or unnecessary traffic congestion, and there were already firemen at the station. The fire trucks quietly drove from the station to the home, located the small fire in the wall and extinguished it. No one knew about the incident until the *Daily Bedford Gazette* ran the story of the "quietest fire" the next day.

KILLED IN A GRAIN ELEVATOR

William M'Aninch had been working in the Red Bank flour mill in Bethlehem for about eight weeks by December 1906. One Friday, M'Aninch was recruited to help unload the grain elevator. When they finished, a belt slipped on the elevator pulley and another employee climbed a ladder to change it. M'Aninch grabbed a lantern and followed in an attempt to learn the process. When the new belt was attached and reactivated, the ladder shook. M'Aninch dropped his lantern and then lost his grip, falling thirty feet to the grain bin below. He broke his neck, and his body was badly bruised. He was

dead by the time the other employee reached him. If the grain had still been inside the bin, it would have cushioned his fall.

MAY PAUL'S WEREWOLF ADMIRER

During the 1850s, a young shepherdess named May Paul lived in Northumberland County. She passed many days on the hillsides and in the fields helping to watch over her family's flock. There was a much older man who lived nearby and was in love with May. He never expressed his feelings to her, but many in the community were aware of how he felt. The man watched her in the fields almost every day.

Many of May's neighbors also raised sheep. One year, the flocks of the surrounding shepherds began to lose sheep to

a predator that appeared to be a wolf. May's flock remained unharmed. One shepherd finally managed to shoot and wound the wolf in the dark one night. The next morning, he followed the trail of blood that was left when the wolf ran off. The shepherd wanted to be sure that he had put an end to the predator. He was surprised when the trail led to the home of the old man who was in love with May.

When the shepherd entered the house, he found the old man lying on the floor with a gunshot wound in the same place he had shot the wolf. The old man was already dead. He was buried nearby, in the area that became known as *die Woolf-mann's Grob*, or "the Wolfman's Grave."

GYPSIES VISIT WARREN

On April 12, 1927, a band of gypsies passed through the town of Warren. They arrived about noon in a half dozen cars and trucks. Their stay was shorter than they had expected. They were promptly escorted through and out of town by the police department. Local papers commended the chief for keeping the "vagabonds" out of town.

HARBINGER OF DEATH

Governor William A. Stone briefly recalled a strange story in his autobiography, *The Tale of a Plain Man*. He heard the

story as a child in Wellsboro in the 1850s from one of his neighbors, John Ainsley. There was a man named Duryea who lived nearby in a large white house on Dean Road. He had once been a sailor and supposedly a pirate. The entire community regarded him as a wicked and evil man. Duryea swore constantly and did not mingle with his neighbors. He even attempted to physically assault preachers who would try to visit him. Many believed him to be in league with the devil.

There was one old woman who went to Duryea's house frequently, but only to clean. One day, she came back and told Ainsley and Andrew Kriner that Duryea was very ill. The two men decided to go up to his house together to see if they could do anything. Though Duryea did not turn them away, he did not want help from a doctor. Later that evening, Ainsley and Kriner were sitting in the house with the porch door open when they saw a frightening animal walk into the house and straight into Duryea's room. It was a large black beast with four short legs and "sharp" eyes. As they watched in disbelief, they heard Duryea scream, and then the beast came back out and left the house. When the men entered Duryea's room, they found him dead. From that time on, the neighbors believed that the devil had come to take Duryea's soul.

BLACK LICK DESTROYED BY FIRE

Much of the mining town of Black Lick was destroyed by a fire on September 29, 1909. An exploding lamp

ignited the blaze that quickly spread from building to building. The entire town assembled to fight the fire, but it was difficult to contain. Eventually, dynamite was used to destroy some buildings in the path of the fire to stop it from spreading. The day after the fire, the loss was estimated at $35,000 by local newspapers, but it was most likely much higher.

NITRATE FILM EXPLOSION IN PITTSBURGH

Just before three o'clock in the afternoon on September 27, 1909, the offices of the Columbian Film Exchange exploded. They were located in the Ferguson Building between Smithfield and Wood Streets in downtown Pittsburgh. The explosion was triggered when a shipping clerk turned on the lights in a small film vault. A spark shot from the light switch and ignited the stacks of highly flammable nitrate film. The clerk slammed the door and ran away just in time. Part of the wall of the building facing Third Avenue was blown out, as were many windows. No one was killed, but the flying glass and debris injured almost seventy-five people inside the building and on the streets below. Police had to close the surrounding streets for hours to make sure that there was no chance of a second explosion.

No Good Deed Goes Unpunished

Twenty-five-year-old Arnold Olds was not expecting to be a hero when he woke up on February 9, 1957. He wasn't expecting to lose his wallet either. Olds was a senior at the Carnegie Institute of Technology (now Carnegie-Mellon University) in Pittsburgh. That afternoon near campus, he saw four boys start to fall through the melting ice in Panther Hollow Lake.

Olds sprung into action. But first, he handed his watch and wallet to two other boys who were standing at the side of the lake. He took off his jacket and shoes and waded into the waist-deep freezing water. Olds managed to pull all four boys to safety. In the meantime, police arrived with blankets and prepared to take the boys and Olds back to the station. It was then that Olds realized that the two boys who had his wallet and watch had disappeared.

The Black Cross of Butler County

The Spanish flu swept the world in 1918 and 1919, claiming many more victims than the First World War, which had immediately preceded it. Some areas were hit exceptionally hard by the killer virus. The small town of West Winfield, on the border of Butler and Armstrong Counties, suffered numerous deaths. In a short period of time, almost three hundred people died. The town did not have the resources

to bury the dead individually, so a mass grave was excavated nearby. It was marked with a black cross.

In the years that followed, rumors of supernatural activity surrounded the site. According to legend, visitors who went to the grave at midnight during a full moon would hear the sound of babies crying. Also, the nearby trees would seem to take on strange and menacing shapes. Sometime in the recent past, the black cross collapsed due to the impact of the weather and vandalism.

FUGITIVE CHICKEN THIEF CAPTURED

In late November 1908, detectives and police in Adams County finally captured the elusive chicken thief, Ambrose Dittenhafer. He was on the run for stealing chickens from the farm of Martin Harman near Hunterstown. The thief was known to be extremely fast and had eluded capture several times before. Detective Charles Wilson, Constable Morrison and a large posse of deputies tracked the witty

thief to his hiding place—his own home. Dittenhafer was a crafty criminal, though, and his wife and sons managed to get in the way of the authorities long enough for him to escape again.

Wilson and his men chased him for three miles through the fog, occasionally firing shots. None hit its mark. Dittenhafer had started to circle back toward his home when Wilson and his men finally caught up. The thief dashed into "Dr. Goldsboro's Thicket" and prepared for hand-to-hand combat with his large stick and razor. By that point, the chase had lasted almost six hours. The police fired several warning shots into the thicket. Finally, Dittenhafer emerged. Wilson's pistol was pointed straight at his head. He surrendered and was taken to the county jail. The saga of the chicken thief was covered with great interest in the local papers.

MAN KILLS TWENTY-EIGHT COPPERHEADS

Mr. Jacob Figley had an encounter with a nest of venomous copperhead snakes near his home in Hopewell Township, Beaver County. Figley's granddaughter spotted the first of the snakes in his backyard while visiting one summer day in 1912. When Figley realized what kind of snake it was, he killed it quickly and then sought out its nest. When he found it, he discovered eight adult snakes and over twenty that were half grown. He killed as many as he could, twenty-eight total, and only a few escaped.

LARGE VEGETABLES

There must have been something special in the soil in the early 1900s in Adams County. A newspaper article from 1909 featured George Hoover's giant tomatoes. He grew them on his Bendersville farm. He had apparently been growing his "beefsteak" tomatoes for several years. That year, he had produced the largest ones yet. He had many tomatoes measuring fifteen and sixteen inches in circumference.

Two years later, M.F. Williams was growing giant turnips on his farm. Some were as large as fourteen pounds.

THE PERPETUAL MOTION MACHINE

In January 1813, a man named Charles Redheffer invited the city leaders in Philadelphia to come to his home to see his amazing invention. What he claimed to have developed seemed impossible—a perpetual motion machine. Eight of the city commissioners attended Redheffer's presentation. Initially, they were amazed. The machine seemed to run without ever needing more power. It seemed like Redheffer had really created the long-sought-after machine. However, one of the commissioners became suspicious when the inventor would not let them get close enough to touch the machine. The curious commissioner managed to get a closer look anyway and realized that there was a hidden set of pulleys keeping the machine moving. He said nothing,

and when the commissioners left, Redheffer was sure that he had fooled them.

Not long after, Redheffer was in city hall. To his astonishment, the city commissioners had constructed their own perpetual motion machine and put it on display. Realizing that his ruse had failed, Redheffer packed up his scam and took it to New York.

Man Found Frozen

William Shank was returning to his home in Big Pool, Adams County, when he stumbled across a man lying in the road. It was about midnight on December 4, 1908. The man was cold, and Shank believed him to be dead or dying. Shank rounded up three men who lived nearby to assist him, and when they moved the man, they realized that he was still alive and that he was Harry Starner's father. Apparently, he had been on his way home and collapsed in the road. The men carried the nearly frozen body of old Mr. Starner to Harry Starner's house. They knocked on doors, yelled and tried many times to wake the family. When no one answered the door, the men decided to leave the old man sitting on the porch.

The family discovered him in the morning, and it took several hours to revive him. The stubborn old man was still holding on to life. He was in serious condition for some time but recovered from his night out in the cold.

Man Collapsed onto Sawmill Belt

Twenty-year-old Luther Spangler was an employee at his father's sawmill near Aspers, Adams County. One day in early December 1908, Luther collapsed and fell onto the belt near the large circular saw. The belt carried him all the way to the top. It was only eight inches wide, but it was moving at a high rate of speed, and none of the other employees could move his body in time. Though he missed the saw, his head got caught between the belt and a pulley. All those watching thought that his neck had been broken. They shut down the machinery and freed him as quickly as possible. Miraculously, Luther was relatively unharmed. He suffered from several cuts and burns to the right side of his face but was otherwise no worse for wear.

The Massacre at Crow Rock

On a pleasant Sunday morning in early May 1791, four sisters went for a walk along Dunkard Creek in Greene County. Elizabeth, Catherine, Susan and Christina were members of the Crow family. The family had lived on the frontier for many years and were accustomed to the dangers that existed there. In recent months, conflicts with the local Indians seemed to have subsided, and they did not expect trouble on their walk.

When the girls approached a large rock, they were ambushed by two Indians and a white man known as "Spicer," who may have been raised as a captive of the Indians. The men took hold of the girls and led them to the top of the rock. After demanding information about local settlements from the girls, they began killing them with their tomahawks. Christina managed to escape after suffering a wound to her neck, and she alerted the rest of her family. A search party was quickly assembled, but it was unable to catch up with the killers. Elizabeth was discovered barely alive, having crawled to the creek after being scalped. She died three days later from her wounds. A small historical marker stands today on the site of the tragedy.

SCHOOLCHILDREN PANICKED

It started out as a normal Wednesday morning at Leisenring No.1 School in Fayette County. It was November 1915, and students were assembling in their classrooms to start the day. One of the children in room five, located on the second floor, was already bored. He started to unscrew the air valve on the radiator, not realizing how much pressure was behind it. Before it was loosened the entire way, the pressure launched the valve across the room, and a cloud of vapor came hissing out of the radiator.

As the vapor filled the room, some of the children began to have trouble breathing and panicked. Miss

Minnie Miller, their teacher, stood in front of the door and tried to calm the students. It was too late. The screaming students pushed her out into the hall and to the stairwell. As the frightened children ran down through the school, they caused panic in other classrooms. Then the fire alarm sounded, and the rest of the students rushed for the exit. Several of them were knocked to the ground, as were a few of the teachers. When the panic finally subsided, three girls and a teacher were injured, though not severely. No one was bored anymore either.

A RAILROAD TRESTLE COLLAPSED

A railroad trestle near Wellsboro was the site of a deadly accident on January 6, 1890. A train full of workers was passing over the trestle that evening when the structure gave way. The engine had made it across, but the rest of the cars were torn free and plunged down into the creek and debris below. Three of the men onboard were killed, and sixteen others were injured. It was believed that part of the same train had struck the bridge earlier that morning when it was travelling in the opposite direction. Unrecognized structural damage might have been inflicted at that point. When the train passed over again, the strain was too much for the trestle to handle.

Fried Eggs in a Basket

A farmer's wife in Alburtis was on her way to a store in Millerstown one day in May 1876. She carried a basket loaded with butter and eggs wrapped in several cloths. At one point, the woman walked alongside the tracks of the Eastern Pennsylvania Railroad. Unbeknownst to her, a live coal from a passing train landed in her basket. The woman continued walking for a while until she heard a crackling noise and realized that there was smoke coming out of her basket. She looked inside to discover that the coal had melted some of the butter and cracked some eggs. The eggs were frying on the bottom of the basket.

A Fatal Ingrown Toenail

Twenty-nine-year-old Harry Meckley died in a York hospital in early March 1912. His cause of death: an ingrown toenail. Three weeks prior to his hospital visit, he began to pick at his ingrown nail, and within days he developed blood poisoning from an infection at the site. He did not immediately go to the doctor, and the infection spread throughout his right leg. By the time he checked into the hospital on March 8, it was too late. He was dead by five thirty that afternoon.

THE NOTORIOUS COOLEY GANG

In the late 1880s and early 1890s, the Cooley gang terrorized residents of Fayette County. Led by brothers Frank and Andrew Jackson "Jack" Cooley and their friend Jack Ramsey, the gang committed numerous robberies and beat and intimidated anyone in their way. The gang had friends and family who would protect them and frequently hid in the mountains to avoid the law. Victims and witnesses were afraid to testify against them for fear of retaliation.

In one instance, the gang broke into the house of an old man named Samuel Humbert and demanded his money. When he did not produce any, gang members bound him and burned his feet to get him to reveal where he had hidden his cash. When that was unsuccessful, they threatened to burn his house and left him bound and gagged on the floor.

The gang used a similar technique a few months later in December 1888. Gang members broke into the house of Mollie Ross near Smithfield and demanded her money. When she refused, they bound and beat her and then burned her feet with candles. She finally told them where she had hidden her money. It was only five dollars.

Not long after, Frank Cooley was arrested for the crime. He was convicted and was awaiting sentencing in December 1889 when he and several other inmates escaped from the penitentiary. They had managed to use makeshift saws to weaken the bars of their cells. Cooley fled back into the

mountains to meet up with his gang. No one chased him. The gang continued its crime spree.

Jack Cooley met his end in July 1892. Jack had been stealing food from the springhouse of Thomas Collier in Georges Township for several weeks. One of Collier's neighbors suggested setting a trap for the thieves. He rigged a shotgun to the door in such a way that it would fire if the door was opened. His intentions were to scare away the thief. Collier's trap worked better than expected and inflicted a fatal wound to Jack.

In September of the same year, the gang invaded the home of Jacob Prinkey near Gibbon's Glade. Prinkey had heard that the gang was in the area, and since he was known for being thrifty and well off, he assumed that he would be a target. He gathered some friends and family to stay at the house, arming them all with pistols and rifles. When the gang burst into the house one Saturday, Prinkey managed to get off the first shot. He wounded two men, one of whom was Frank Cooley. The gang members soon disarmed the family and, after tending to their wounded friends, proceeded to ransack the house and take items of value. They only found twenty dollars in cash because Prinkey was smart enough to deposit the rest of his money in a bank before they arrived.

Finally, in early October, Sheriff George McCormick and his men put an end to the outlaws' crime wave. The sheriff had learned that one particular Sunday Frank Cooley was to visit his family on their farm. Since it was almost impossible

to catch the gang in the mountains, he thought it would be best to catch its leader off guard. His men closely watched the farm and waited for Cooley to leave. When he walked out to a path in the woods with another man, thought at the time to be Jack Ramsey, the sheriff sprung his trap. He caught them at the edge of a clearing and demanded that they throw up their hands and surrender. Both men turned and ran back toward the Cooley farm. After about twenty-five feet, both turned and fired on the pursuing officers of the law. Their shots missed. They climbed over a fence and headed across a clover field when Frank turned and fired at the sheriff again. Both of his shots missed, but one of the sheriff's deputies aimed carefully and hit him in the back while he was trying to hide behind a tree.

Frank crumpled to the ground behind the tree but kept firing one of his revolvers until it was empty. The sheriff closed in on him and asked him to throw the weapon down. Frank complied, apparently resigned to his fate. The sheriff said, "Frank, I am sorry that it had to happen this way." Frank supposedly replied, "You're not to blame, George. You did your duty." Half a minute later, he was dead.

The man who had been with him escaped, but it didn't matter. Jack Ramsey was picked up a few days later, and the Cooley gang was devoid of leadership. The gang never recovered, and its remaining members fled into West Virginia. Several family members and friends of the Cooleys were arrested for aiding the criminals and receiving stolen property.

HEXENKOPF HILL

Hexenkopf Hill has long been a center of supernatural activity. The hill is located south of Easton in Northampton County. The name *Hexenkopf* means "Witch's Head" in German. According to the legends, a variety of groups have used the hill to practice forms of magic. Local Indian tribes were said to perform rituals there that drove evil spirits from their sick and dying brethren and imprisoned them in the hill. For decades, the people who lived nearby said that the hill would glow at night because of the imprisoned spirits.

The area around the hill was settled primarily by German immigrants. In the early 1700s, women who practiced witchcraft supposedly met on the hill on certain evenings. They allegedly performed rituals, danced and sang strange songs. In the 1800s, the hill was utilized by practitioners of Pennsylvania German folk healing and magic known as powwowers or *brauchers*. These folk healers used the hill in a way that was similar to the Indians. There was a particular rock on Hexenkopf called the Witches' Rock. The *brauchers* used their rituals to transfer illness from their patients into the rock. Other rituals and prayers were performed on the hill as well.

In more recent times, rumors have spread of satanic cults and witches' covens performing their dark ceremonies on the hill. Hexenkopf also has the reputation of being one of the most haunted places in the state. All of the spirits

that have been imprisoned there over the centuries wander the hill, forever tied to the earth.

CENTRALIA–THE BURNING TOWN

Centralia was a small anthracite coal–mining town in Columbia County. Founded in the mid-1800s, the town's biggest claim to fame was as a center of activity for the Molly Maguires in the 1860s and '70s. That is, until the fire started. No one is sure exactly how it happened, but it is suspected that it started as a landfill fire in 1962. The local fire department had frequently carried out controlled burns in the local landfill to reduce its size. That year, however, a new landfill was being used, and it occupied the site of a former strip mine. The fire never went out completely as planned. The borough had failed to construct the clay barrier that was required by law to prevent fires from spreading.

The fire spread into the maze of abandoned coal mines that ran under the town and surrounding countryside. It has not stopped burning since. Several attempts were made to extinguish the blaze, but they all failed. The townspeople only became aware of the full extent of the problem in 1979, when the local mayor/gas station owner realized that the gasoline in his underground tanks had reached 172 degrees. Other residents complained of noxious fumes and subsidence on their property. It quickly became clear that

Centralia was doomed. In 1984, the government provided $42 million to relocate the residents of the town. Most took advantage of the offer, with only a few stubborn residents staying behind. The town's population dropped from over one thousand to fewer than ten today.

Most of the town's structures have been torn down. It is little more than a ghost town, with steam and smoke rising from cracks in the streets. Nearby PA Route 61 had to be closed because the fires caused too much damage to the road. Enough coal remains under the town for the fire to burn for well over two hundred years.

McKees Rocks Indian Mound

A burial mound was constructed by the Adena people (also known as the Mound Builders) in present-day McKees Rocks next to the Ohio River. The mound was built sometime around 250 BC and stood sixteen feet tall with a diameter of eighty-five feet. It was partially excavated in 1896 by the Carnegie Museum. The dig uncovered thirty-three bodies, along with artifacts and ritual objects. The mound had been constructed in three stages and was used by several generations of the Adenas and their successors, the Hopewell culture. Today, the back half of the mound still exists and is recognized with a historical marker.

GIANT CATFISH

Rumors have circulated for decades about giant catfish living in the Ohio, Allegheny and Monongahela Rivers. They are said to reach enormous lengths of ten feet or more. According to the stories, some of the fish are large enough to swallow a diver. Supposedly, some divers and engineers are reluctant to work on bridge pillars and dams because of the giant fish. Their large size is attributed to mutations caused by the pollution that once contaminated the rivers during the region's era of heavy industry.

HOW TO STOP A WEREWOLF ATTACK

Since Pennsylvania seems to have so many werewolves, it would probably be helpful to know how to stop one if you were attacked. Luckily, there was a man who knew how to quickly put an end to such an unpleasant experience. The well-known hunter and storyteller Daniel Kerstetter, who lived from 1818 to 1898, passed along advice on how to stop an attacking werewolf. He claimed to have heard the method as a young man from people who were much older than himself. Folklorist Henry Shoemaker recorded the method. Kerstetter said that one should use a dagger or a sword cane to prick the creature between the eyes, on the ears or

anywhere on the head where a lot of blood would come quickly. The werewolf will then quickly change back to its human form. Kerstetter insisted that he knew of many lives that were spared by using this method.

HOW TO KEEP WITCHES AWAY

Since you now know how to ward off those pesky werewolves, it might also help to know how to keep witches away. The folklore of the Pennsylvania Germans is full of recommendations to drive off witches. (Although most of these recommendations would drive off anyone.) For example, if you nail a toad's foot above a stable door, it will prevent a witch from entering and hexing your animals. The foot of a goose with a pentagram drawn around it will serve the same purpose. If you want to keep witches from your home, you should place a sprig of St. John's wort above your doors. Perhaps the most gruesome method to keep witches away from you and your home is to cut off the ears of a black cat, burn them to ashes and feed them to the witch by adding them to another food. The witch will stay away (and it is quite possible everyone else will too).

THE STEEL DRESS

If any part of the world were going to invent a steel dress, it would have to be western Pennsylvania. It should come as no surprise, then, that Val Schnitski designed a dress in 1962 that was made of steel sequins. The sequins were manufactured at the Armco Steel Plant in Butler County. After the steel dress received high honors at a competition sponsored by the Pennsylvania Hairdressers and

Cosmetologists Association, word of the creation spread in the fashion world. The dress went on tour for several years, visiting France, Switzerland, Belgium and various places in South America. As is the case with all fashion, after a few years interest died away. The current whereabouts of the dress are unknown.

THE MEANING OF RIVER NAMES

Pennsylvania's rivers have some strange names. Often these names are of Indian origin and have a very simple meaning. The Susquehanna is one such river. Moravian missionary John Heckewelder thought that the name translated as "the long reach river" or the "great bay river." In the Algonquian dialects, it means "muddy river." The Lackawanna River, in the northeastern part of the state, owes its name to the Lenape, or Delaware, Indians. It means simply "the stream that forks." Another river name with a similar meaning is the Lehigh River. Lehigh is an English version of the Lenape word *Lechewuekink*. It translates as "at the forks" or "where there are forks."

The Juniata River also has a name that is an anglicized version of an Indian word. The original word is *Onayutta*, or "standing stone." The Onojutta-Haga Indians once had a fifteen-foot-high standing stone near present-day Huntingdon. It was said to be inscribed with their history and beliefs. The tribe took the stone with them when

they were driven from the area in 1754. It has never been found.

In the western part of the state, there is the Allegheny River. While it is a Lenape word, its exact meaning is not necessarily clear. It may translate as "fine river," or it may be a reference to a legendary tribe called the Allegewis or Tallegewis, who were enemies of the Lenapes. One tributary of the Allegheny, the Kiskiminetas River, also has a name whose origin is not clear. Suggested translations have included "clear, clean stream of many bends," "place of the largest stream" and "river of big fish."

Luckily, the Monongahela River has a name that could be translated more easily. It means "falling in banks." The Youghiogheny River, which feeds into the Monongahela, translates roughly as "winding stream" or "stream flowing in the contrary direction."

All of these western rivers eventually flow into the Ohio River. Though it is often thought to have meant "beautiful river," several other translations have been suggested. The Lenapes called it *Kit-hanne* or "great river." Other translators have suggested "bloody river," which is not considered to be accurate, or the more likely "stream that is very white."

THE HOOP SNAKE

One unusual animal legend that circulated in the mountains of Pennsylvania for many years was that of the hoop

snake. Variations of this legend have been found throughout the United States and Australia, but the legend was particularly strong in this state. The mythical snake was said to be as long as a large rattlesnake or a blacksnake, with a venomous horn or stinger on its tail. The German settlers called it *die Hannschlang*. The reptile would put its tail in its mouth and roll through the woods in the form of a hoop. The snake traveled that way until it caught whatever it was chasing or until it ran into something. When it struck an object, usually a tree in the stories, the snake would uncoil and strike with its tail. The unfortunate tree would turn blue and die. If it struck wooden objects, such as tools or fences, they would also turn blue and swell to more than double their original size. If a person were caught off guard by the snake and found himself unable to hide behind something, he would suffer an agonizing death from the serpent's poison.

THE CORN MONSTER

The Corn Monster was the name given to a bigfoot-like creature that was supposedly seen around Mount Davis in

Somerset County during the 1970s. Most of the sightings were reported by farmers, who spotted it in their fields. The monster seemed to have a liking for corn and picked it directly from the stalks. Upon investigation, husks and cobs were found scattered on the ground where the Corn Monster had been.

An Explosion over Pittsburgh

On June 24, 1938, something exploded in the sky about twelve miles above the city of Pittsburgh. The explosion had an estimated force of ten thousand tons of TNT. It was assumed that the source of the blast was a meteor that did not make it to the ground.

Gravity Hill

There are a few places in Pennsylvania where the adventurous have been defying gravity for years. These places are called gravity hills. Supposedly, the law of gravity does not seem to completely apply in such locations. Balls, cars and pretty much anything else that can roll ends up going in the wrong direction—uphill! Water and other liquids that are poured on the ground also travel uphill. Suggested explanations for the phenomenon include optical illusions, magnetic anomalies and even various paranormal

causes. While there are several gravity hills throughout the state, the best of them is located near New Paris, Bedford County. There are actually two gravity hills at that location, both on the same road, one right after the other. They can be found off Bethel Hollow Road (State Route 4016).

It is not clear when the hills were first discovered, but someone took the time to mark the site of the first gravity hill with two GHs, which are spray-painted on the road. Visitors are supposed to drive their car to the second GH, put it in neutral and watch the car roll back uphill to the first GH. The second unmarked hill is three-tenths of a mile past the second GH.

Another gravity hill is located at McKinney and Kummer Roads in North Park, Allegheny County. On the other side of the state there is a gravity hill on Buckingham Mountain in Bucks County. Local legends have tied the strange effects there to black magic and evil cults. In Elk County, there is a gravity hill near Brandy Camp off Route 219. At that hill, it is said that a ghost horse can be heard galloping nearby. There is even a small gravity hill inside the Laurel Caverns in Fayette County.

GOLD HIDDEN NEAR THE OLD KINZUA BRIDGE

In the summer of 1893, a bank was robbed in Emporium. The robber took over $40,000 worth of gold coins and fled into the wilderness of northern Pennsylvania. After many

days of traveling, he became very ill and stopped within sight of the Kinzua Railroad Bridge in McKean County. There, he buried the stolen coins in glass jars beneath a triangular rock. The man staggered into Hazelhurst, where he died several days later, but not before telling his story. Numerous attempts have been made to find the coins since that time, but none has been successful. In 1900, a new bridge replaced the original. It stood until 2003, when it was destroyed by a tornado. The area around the bridge is a state park.

WITCHCRAFT HYSTERIA IN VENANGO COUNTY

Sometime around the 1840s, there was a brief outbreak of hysteria over the alleged practice of witchcraft near Dempseytown, Venango County. The story was told by Joseph Kean in 1879. He omitted the names of most of those involved to protect the families who were still in the area. It started with a young woman of "respectable parentage" who began acting very strangely. She had strange fits, and her behavior was described as deranged by at least one observer. The young woman said that she experienced a roaring noise in her ears and double vision during the fits. Though the girl had never mentioned witchcraft, some of her neighbors began to talk about it. They managed to convince the girl and her parents that she was bewitched. More residents of the town came to see

her and the fits and told their own stories of witchcraft. It wasn't long before the young woman came to believe that another "respectable" Irish woman in the neighborhood was the witch who was oppressing her.

Her neighbors and family tried to battle the witch with their own folk-magic beliefs. They brought George Shunk, a seventh son, to see the girl while she was being attacked. He waited for the girl to point in the direction of the invisible witch, and then he swung a heavy club in that direction. The witch always dodged the blow, of course. Then another friend suggested that a witch could not cross moving water, so they took the girl to the other side of Sugar Creek. Apparently, the helpers failed to clear the stream of debris, and the invisible witch was able to cross on a log. The fits continued for several weeks. More remedies were tried, such as horseshoes nailed above the door, but they all failed.

By this time, everyone in town was discussing witchcraft. Every evening, more people would appear to watch what happened to the girl. They all prayed and invoked folk remedies and charms. Still, nothing worked. A man was brought in who claimed to have been a witch killer back in Germany. All of his attempts to drive away the curse failed too. He said that American witches were "too cunning." Some of the visitors started seeing strange things happen around the young woman's house. Even those who were initially skeptics became convinced that witchcraft was real. When cattle and pigs became sick on local farms, they feared that the curse of the witch was spreading.

Eventually, the accused witch and her family filed lawsuits against those who were defaming her. The hysteria soon died away. Miraculously enough, when the young woman received treatment from an actual doctor, the strange fits ceased and the ringing in her ears stopped.

A RAINY DAY

If you are in Waynesburg, Greene County, on July 29, you had better bring your umbrella. It does not matter if you are there this year, next year or ten years from now. You will need it any year on that date. It almost always rains on July 29 in Waynesburg. Locals started keeping track of the strange weather phenomenon in the 1870s, when a farmer walked in to Daly and Spraggs Drug Store and mentioned that it had been raining on his birthday, the twenty-ninth, for several years.

Byron Daly, the pharmacist, used that piece of information to start betting prominent people in town that it would rain on July 29. They often wagered for a new hat. Soon, Daly had built up quite a collection. He continued the tradition for years, only losing twice. When he died, his son John continued wagering for hats. Over the years, it became a custom to bet with a local or national celebrity. Numerous celebrities turned over well-made hats to Daly and, more recently, the Special Events Commission that runs Rain Day festivities in the town.

Rattlesnake Pete

In the summer of 1880, a strange man was discovered living in the hills above Erwinna, near the Delaware River. Known as Rattlesnake Pete, the sixty-year-old man had been living in the woods with his dog and pet rattlesnakes for decades. He roamed the wilderness gathering the snakes, of which he had no fear. He claimed that as a child, he and his siblings had a lot of experience dealing with the reptiles, and he learned how to train them and kill them if necessary. The snakes roamed free in the small shack where he lived and never attacked him or his dog.

Battle at the Circus

The Wallace Circus was in Mahony City, Schuylkill County, on May 28, 1891, for one of its usual performances. The circus employees did not anticipate that they would never finish their show that night. Around the time the performance started, a group of boys, whose ages ranged from fourteen to eighteen, tried to force their way into the circus tent. The doormen pushed them back, but the boys stuck around outside and shouted insults. Some of them screamed so loud that they disrupted the performance inside.

Slowly, more people gathered outside and joined in. By ten o'clock that evening, there was a large crowd. The crowd surged forward to get into the tent, and this time

the doormen could not stop them. Soon, a full-scale riot had broken out. Some of the performers were dragged and assaulted. The other circus employees and canvasmen grabbed clubs and began to beat back the crowd. Even that was not enough to hold back the throngs of people, so some of the performers got hold of revolvers and rifles and fired over fifty shots into the crowd. This bought them enough time to flee back to the circus train and load what they could carry. The engineer quickly pulled the train away from the station, and the circus proceeded to the next town. It was unclear exactly how many circus personnel were injured, but seven men who were in the rioting mob were badly injured, two of them critically.

The town constable attempted to arrest the circus employees before they pulled away. When he and his men attempted to board the train, they found themselves face to face with the barrels of several rifles. They let the train go.

A BAN ON DANCING

When the Reverend John Marquis came to the Pigeon Creek Presbyterian Church in the early 1880s, he decided to crack down on one particularly evil vice that had crept into the community. Apparently, some members of the small congregation near Monongahela City were engaged in the sin of dancing. Several stern lectures to the congregation had failed to produce the intended results. The problem

was widespread among the young people and even a few married couples. Reverend Marquis decided that it was time to refuse communion to the dancers, and during the service on December 31, 1882, he told anyone who had danced that year to stay in their seats. Seventy-four members of the congregation remained seated. Twelve later repented. The remaining sixty-two were suspended until they recognized the severity of their sin. They had until March 1883 to repent. If they did not, they faced possible expulsion from the congregation. Reverend Marquis' campaign against dancing even made it into California newspapers. It is not clear how many members returned after March.

Don't Eat the Yellow Snow

In March 1879, a blanket of yellow snow fell on South Bethlehem. (Note that the snow was yellow before it hit the ground.) Samples of the snow were examined by the surgeon general of the U.S. Army. He concluded that the snow was saturated with pollen that had blown north into Pennsylvania.

Sam Scott–Philadelphia's Famous Jumper

Samuel Scott of Philadelphia became famous for his amazing jumping and diving abilities. He performed

a variety of daredevil feats in front of audiences in the late 1830s and early 1840s. Scott first began jumping in the navy, where he was known to dive from the masts of ships. He always jumped into water, often from bridges or cliffs. Onlookers would put money in his hat after his performances. Soon, he began traveling up and down the East Coast and even made a dangerous jump from Niagara Falls. As time went on, he added more tricks to his act, performing acrobatics with a noose around his neck. By 1840, he had raised enough money to take his show to England. Unfortunately, neither he nor his act lasted very long in Europe. In early January 1841, he was performing at the Waterloo Bridge when he accidentally hanged himself with the noose with which he was performing. All attempts to revive him failed.

AIRCRAFT ENGINEER SAW UFO OVER ERIE

As a research engineer specializing in aircraft instrumentation and magnetism, Victor Didelot was familiar with the way traditional aircraft moved. What he saw above the city of Erie in the summer of 1958, however, was beyond his ability to explain. Didelot saw a silvery white, oval-shaped object perform an incredible maneuver. He said that the object moved horizontally, parallel to the ground, in a 120-degree arc that followed the shoreline of Lake Erie. When it was over the city, it

abruptly shot directly up into the sky at what he estimated was three times the speed than that at which it had been traveling previously. Didelot also noted that the object made no sound.

A Strange Vision

In 1878, an engineer named Bill Sandusky worked for the Philadelphia and Erie Railway. He was known as one of its most skilled and reliable employees. Bill's friend and fireman on the train Jimmy Green had been killed that year after falling underneath the train while saving the life of a young child. Sandusky was assigned a new fireman—a strange young man named George Watkins.

None of the other engineers knew where Watkins was from. He had only been working for the railroad for a few months. Watkins was about twenty-two years old but looked much older. Sandusky described him as tall and lean, with a dark complexion and dark, sunken eyes. Most of the railroad men felt uneasy under Watkins's gaze and did not look him in the eyes.

After about a month, Watkins was making Sandusky so uneasy that the engineer asked the superintendent for a new fireman. His request was refused because Watkins had been doing his job well, and there was no reason to transfer him. Then something strange happened one day while the train was passing through a wooded area of McKean County.

Sandusky happened to look back at Watkins, who seemed to be staring at him intently. As the young man turned toward the outside scenery, so did Sandusky. Suddenly, the trees were gone, and there was a vision of a small town on a large flat area. He saw an old man riding toward the town on a horse. A young man stepped out from behind a tree and shot the man on the horse. The old man fell to the ground, clutching his chest. The murderer shot him two more times while he was down. Then the vision ended and the trees reappeared.

Sandusky turned back toward Watkins in shock. Watkins had apparently not seen the vision, so Sandusky described it in detail. As he did, Watkins grew pale and blurted out, "My God! There is no escape!" He jumped from the train and disappeared into the woods. Sandusky stopped the train to find him but had no success. Watkins never returned to work.

A few months later, Sandusky was on vacation in Cincinnati when he picked up the morning paper. He read about a man named Walters who was going to be executed across the Ohio River in Kentucky for shooting and robbing his uncle six years earlier. For some reason, the story made Sandusky think about the vision he had on the train, so he went over to Kentucky to see if he could get a look at the killer. He was allowed to look into the murderer's cell. It was the man he had known as George Watkins. Sandusky had seen a vision of him committing the crime. After Watkins/Walters jumped off the train, he had returned to Kentucky to confess. He was executed three days after Sandusky's visit.

THE HEADLESS FRENCHMAN

Twin Sisters Hollow in Potters County is allegedly haunted by the ghost of a headless Frenchman. According to the legend, the unfortunate man was part of the expedition led by Etienne Brule that explored parts of North America in the early 1600s. The Frenchman was ambushed by hostile Indians (possibly while looking for silver), and his head was cut off. His ghost can be seen walking under the full moon in October, with his severed head held under his arm.

THE WORLD WILL END ON APRIL 1, 1940

That is what a press release from the Franklin Institute in Philadelphia said on March 31, 1940. The release claimed that the astronomers at the institute guaranteed that it was no April Fools' joke and the world would come to an end at 3:00 p.m. Eastern Standard Time the very next day. The message went on to say that confirmation of the announcement could be obtained from the director of the Fels Planetarium. The press release might have gone relatively unnoticed, but it was broadcast over the air by radio stations. The station and the Franklin Institute were bombarded with panicked inquiries. The institute announced that it had made no such prediction and sent out no official press release. It was soon discovered that William Castellini, who was involved with public relations

at the institute, sent out the fake press release to publicize an upcoming lecture that was going to discuss ways in which the world might end. The institute did not find his prank amusing and fired him.

THE FIRST CREMATORY IN THE UNITED STATES

Dr. Francis J. LeMoyne was a prominent physician in the city of Washington, Washington County, throughout the mid-1800s. LeMoyne became convinced that local burial practices were causing some of the illnesses that he was treating. He believed that the decomposing bodies and the illnesses that they contained were leeching into the soil and contaminating local water supplies. He offered the local cemetery money to construct a crematory on its property, but the offer was rejected outright because of the unpopularity of cremation. Not to be deterred, he constructed his own crematory in 1876 on Gallow's Hill for a cost of $1,500. He designed the "oven" himself so that the bodies would not be exposed directly to the flames. LeMoyne was not just the owner—he was also a client. His body was the third to be cremated in the building in 1879. The building still exists and is maintained by the Washington County Historical Society.

A DYNAMITE EXPLOSION

In March 1883, four workers attempted to thaw frozen dynamite in Dead Man's Hollow along the Youghiogheny River in Allegheny County. The men were working at a stone quarry run by George Fleming. The four men were to continue the blasting that had been carried out by the previous shift. The foreman was David Henninger, and he was helped by his brother George, Noble Gilkey and an unidentified black man. As they were preparing to work, they discovered that the dynamite cartridges had frozen, so they built a small fire and placed the explosives a few feet away to thaw. This was not the best idea. The men also took the opportunity to warm their hands near the fire.

After a few minutes, the dynamite exploded. The Henningers, who were standing closest to the dynamite, were torn to pieces, and David died instantly. George lingered for a short time before dying. The unidentified black man sustained severe wounds and burns and was not expected to recover. Gilkey was severely burned on parts of his body, but it was thought that he stood the best chance of recovery. Luckily, Gilkey's house was within sight of the accident, so help was summoned immediately.

A GANG ATTACKS A CHURCH

In March 1887, the Clarion County Jail released Sam Schnell after he served a six-month sentence for various crimes. He returned to Turkey City and celebrated with his fellow ruffians, including several members of the McCleary family. The group became extremely intoxicated and decided to settle some old scores. They staggered off to the local Methodist church. The Reverend J.H. Laverty was hosting a revival meeting, and he was in the middle of the service when the gang forced its way in and caused a disturbance. D.H. McLaughlin, one of the trustees of the church and a critic of the McClearys, got up and attempted to force the men out. They responded by knocking him to the ground and repeatedly kicking and beating him. The rest of the congregation fled out the windows.

When McLaughlin was almost unconscious, the gang proceeded to smash the pews and windows. Then it went outside and destroyed a carriage parked nearby. When McLaughlin recovered, he went to the police, and arrest warrants were issued for the gang. The only member of the gang who was caught right away was a man named Lincoln Giger. The McClearys escaped to wreak havoc another day.

A Pig-Stealing Bear

The *St. Louis Globe-Democrat* ran a story in 1886 about a pig-stealing bear in Clinton Township, Pennsylvania. Unfortunately, it failed to mention which Clinton Township. The story is interesting nonetheless. Hiram Cole and his helper, Silas Olmstead, were clearing and burning brush on Cole's farm one day when Cole's twelve-year-old son came running over excitedly. He told them that a bear had broken into the pig pen and was leaving with one of the young pigs. The men ran quickly to the yard, but they saw no pigs there. They did, however, hear squeals and noises coming from the orchard. When they reached the orchard, the men saw that the sow and her litter were chasing after the bear squealing. One of the young pigs was still clutched in its mouth.

The men grabbed some clubs and a wooden fence rail and pursued the bear. In the meantime, it had climbed another fence, so the sow and the other young pigs could no longer follow it. The farmer and his helper ran a little ahead of the fleeing bear. The men then stuck the rail in front of its legs and tripped it. The bear tumbled to the ground and struggled to get up while holding the now dead pig in its mouth. Cole and Olmstead then proceeded to trip the bear several more times. It became enraged, but the men continued to knock it down every few steps. When it charged them, the men were quick enough to move the rail and trip it again. Cole finally thrust a knife

into its throat after it fell the final time. The men backed up quickly, and the bear stumbled around and roared. Cole had struck an artery, and the bear was dead in a few minutes. Cole paid Olmstead an extra twenty dollars for battling the bear with him. The bear's skin was made into a sleigh robe for Cole's daughter.

The Phantom Boatman

In 1784, a story spread that a ghostly boatman was seen traveling at midnight on the Schuylkill River. The living skeleton was supposedly sighted near Fairmont Ferry. The story spread quickly, but it turned out to have been entirely fabricated. A young couple had decided to play a practical joke on their neighbors.

The Collapse of the Austin Dam

The fifty-foot-high Austin Dam was constructed in the Freeman Run Valley in Potter County in 1910. It was built to provide water for the Bayless Pulp and Paper Mill, which had been constructed in the valley in 1900. The mill had begun to suffer water shortages because of seasonal conditions, so a dam was necessary to maintain the supply. George Bayless hired civil engineer T. Chalkey Hatton to assist with the construction. When it came time to figure out expenses, Bayless often ignored the recommendations

of Hatton and opted for cheaper methods of construction. The results would be tragic.

By January 1910, the dam was severely bulging because of an early thaw. The concrete had cracked, and dynamite had to be used to blast away part of the dam because no overflow had been installed. Needless to say, the situation made both the workers in the mill and the people in the town of Austin uneasy.

On September 30 of the following year, tragedy struck. It was Saturday, and the town was full of shoppers and people attending political events for the upcoming elections. Some people heard the cracking and tried to alert the town. The dam finally gave way, sending water and huge pieces of debris crashing through the valley. A cattle fence was pushed along with the water, ensnaring helpless victims. Many were crushed by huge pieces of stone and trees. One woman, whose leg was crushed under a boulder, pleaded with the men nearby to cut off her leg to save her. Eventually, a Polish immigrant took an axe and freed her, carrying her to the hospital. Houses were torn to pieces. Some witnesses described the initial wall of water as being fifty feet high.

When it was over, seventy-eight people were dead. Hundreds of others were injured. The paper mill and much of the town was destroyed. At the time, the losses were estimated at $10 million. The state did not deliver any disaster assistance. Relief work was carried out entirely by volunteers. The paper mill was eventually rebuilt with a new dam. The mill burned to the ground in 1933. The second

dam collapsed in 1942, causing much less destruction than the first.

THE FATE OF *Le Griffon*

The French explorer La Salle charted much of the interior of the United States during the late 1600s. He constructed his boat, *Le Griffon*, in the winter of 1678–79 so that he could explore the Great Lakes. La Salle used the boat to travel from Niagara River to Lake Michigan, making stops along the way. Later that year, when La Salle was not onboard, the ship was said to be lost in a storm on Lake Huron. La Salle suspected that some of his men had scuttled the ship and made off with his trading goods. There was no conclusive evidence as to what happened to the ship. It is called the holy grail of Great Lakes shipwrecks.

At least a handful of people in northwestern Pennsylvania believed that they knew the location of the legendary vessel. In the swamps near Pymatuning, a story was passed down about *Le Griffon* until the 1930s. A few residents claimed that the remains of a very old ship could be found hidden in the swamps. Though the wood was rotting, it supposedly had some brass ornamentation. The people who recounted the tale believed that the old boat was in fact La Salle's missing ship.

By the time a serious investigation could occur, the remains could no longer be located. It was unlikely that *Le*

Griffon ended up in the swamp, even if it had been stolen. The actual boat may have been discovered recently in Lake Michigan, but this has yet to be confirmed.

THE SIREN OF LOYALSOCK CREEK

Sometime during the mid-1800s, an Indian woman was supposedly murdered by a raftsman on Loyalsock Creek in Lycoming County. Her name was said to be Cicely Powderhorn, and she was of Mingo descent. Every evening, Cicely met her lover, William, on the large rocks near the creek. While she waited, she would sing beautiful songs that were said to make even the forest become quiet. She would watch raftsmen float past with their goods. They all enjoyed her singing, except one. One day, William was late, and an envious raftsman lodged his raft near the rock and approached her. He attempted to force himself on her, but she fought back. The enraged raftsman grabbed her around the throat and choked her to death.

William was approaching the rock on a raft and was forced to witness the horrible event from a distance. He rowed as fast as he could, but by the time he reached the rock, the raftsman was already headed downstream. The law did not help the Powderhorn family because they were Indians, and the killer was not brought to justice.

Not long after the murder, nearby farmers testified that they could still hear Cicely singing near the creek.

Of course, she wasn't actually there. That particular stretch of the creek was treacherous and usually required the full concentration of the raftsmen to navigate. Soon, many of them began to hear the song of Cicely as they traveled past the rock on which she was killed. It mesmerized them, causing many to wreck their rafts on the rocks. The haunting song was heard for several years, until a half-crazed man visited a farmer who lived near the creek. The man asked repeatedly about the Powderhorn family and eventually admitted to killing Cicely. He wanted to know why the family had been tormenting him by singing every time he passed the

rock. The farmer, who had been a friend of Cicely, acted as if he didn't care. The man left, and the farmer told the next group of raftsmen who came through that he had identified the killer. After hearing the description, the other raftsmen set out for revenge. They managed to capsize the killer's raft in the rapids not long after. The killer was crushed against the rocks and drowned. The raftsmen buried him in an unmarked grave. As they did, they heard the song of Cicely one final time.

THE FIRST FERRIS WHEEL

The very first Ferris wheel was designed by a bridge builder and engineer from Pittsburgh named George Washington Gale Ferris Jr. Ferris was running his own business, G.W.G. Ferris & Co., which inspected and tested structural steel for the state's numerous bridges and railroads, when he came up with the idea to build the wheel. The first wheel was constructed for the Columbian Exposition in Chicago in 1893, and it instantly became a hit. It stood 250 feet tall and could hold 2,160 people. Passengers paid fifty cents each to ride the wheel through two revolutions. The idea was quickly copied and spread around the world.

JOHANNES KELPIUS AND THE HERMITS
OF WISSAHICKON

Johannes Kelpius was a German Pietist immigrant who came to Pennsylvania because of its policies of religious toleration. He was born to German parents in Transylvania in 1673 and acquired a master's degree in theology at a German university by the age of sixteen. Kelpius was also very interested in math, astronomy, botany, music and the occult. He became a mystic and intently studied the Bible, especially the Book of Revelation. In the 1690s, Kelpius and some like-minded followers came to Philadelphia so that they could continue to develop their ideas in peace. Kelpius became convinced that the world would end in 1694.

The mystic and his followers lived lives of celibacy and prayer in the hillsides along Wissahickon Creek. Many lived in caves or simple houses, writing books and music and producing medicines with their botanical skills. Though the surrounding community called them monks, they referred to themselves as the Society of the Woman in the Wilderness, in reference to one of their biblical interpretations. The hermits were frequently sought out for their knowledge of medicine and their understanding of numerology and astrology. When the world did not end in 1694, the date was reinterpreted and pushed forward several times. When Kelpius died in 1708, the society disbanded. Some members joined the similar Ephrata

Cloister, while others chose to marry. The cave of Kelpius and several others still exist today.

THE EXPLOSION OF THE *Island Queen*

On September 10, 1947, the excursion steamer *Island Queen* exploded at the dock along the Monongahela River in Pittsburgh. The boat was 285 feet long and 50 feet wide, making it one of the largest on inland waters. It had five decks and the capacity to hold four thousand. Sixty crew members were onboard at the time of the blast, but luckily there were no passengers. Twenty-one of the crew members were killed and eighteen were wounded. Some were thrown more than 30 feet away into the river. The blast also damaged cars and buildings along the river. Fireboats extinguished the fire and rescued the survivors. The blast was most likely triggered by an acetylene torch.

THE PUMPKIN FLOOD

In September and early October 1786, much of the state was inundated with heavy rains. The massive amounts of rainwater caused the Susquehanna River and its tributaries to swell. By October 6, the waters spilled over the riverbanks and washed away vital crops that were soon to be harvested. Those who witnessed the flood reported that hundreds of

pumpkins could be seen floating down the river, washed away before they were picked. Because so much food was lost, many farm animals starved to death over the winter, causing financial hardship for many farmers.

A Crime Spree and Shootout

Twenty-six-year-old Albert Feelo, twenty-seven-year-old Virgil Evarts and thirty-three-year-old Kenneth Palmer had all served time together in Rockview Penitentiary during the 1930s. All three were troublemakers, and when they started working together, things got out of hand. After they were released, they originally planned to find legitimate employment. Their plans did not last long. In early September 1941, the three men met up at a bar in Uniontown. For the next two weeks, they committed a series of crimes in western Pennsylvania.

First, the three men went to Farrell, forced their way into the Francke & Co. Insurance offices and held up the business. Several secretaries and the manager were tied up and left on the floor while the safe was broken into. The robbers took $400. Their next stop was a gun store in New Castle. This time they took guns, ammunition and $100 in cash. By September 19, the men had traveled to Butler to rob the Harrisville Bank. Pointing their guns in the employees' faces, they threatened to kill anyone who did not comply. The thieves made off with all of the money that was left in the bank, about $2,300.

A man who was working in the hardware store next to the bank witnessed the robbery. As the three men were getting back into their stolen car, he called the police and gave them a description. The men had taken off in the direction of Ellwood City. Chief Ernest Hartman received the call at the Ellwood City station and took down the details. The chief then grabbed a Thompson submachine gun and headed out alone in his car to intercept them. Hartman pulled his car next to the Fifth Street Bridge and kept a watch on the road.

He only waited a few minutes before the stolen getaway car approached. Hartman stepped out to stop the car and told the men to put their hands in the air. Instead, the robbers drew their pistols and fired. They missed Hartman and were not prepared for the barrage of bullets from his Tommy gun. All three were hit. They managed to climb back in the car and sped off again. Hartman did not know it at the time, but he had hit Feelo in both lungs and his spine.

As the wounded men fled from Hartman, an off-duty police officer, Edward Shaffer, joined in the pursuit in the car of drugstore clerk James Pasta. The two were closing in when Evarts lost control of the getaway car on Belton Road and went over a ten-foot embankment. Only Palmer and Evarts climbed up to the road, where they stopped a car driven by Angelo DeCarlo. His passenger was Mrs. Laura Kash, whose car had just broken down up the road. Evarts ordered the pair to get Feelo from the car and carry him

to DeCarlo's car. Before they had a chance to climb down the hill, Shaffer and Pasta arrived on the scene, ahead of Hartman. Shaffer was unarmed, so the thieves now had four hostages. They made Shaffer and Pasta carry Feelo to the car. Evarts then ordered Shaffer into the front seat, and he set his rifle on Palmer's lap while he walked over to the driver's side. He didn't count on Pasta's quick hands. Pasta snatched the rifle and pointed it at Evarts. While Palmer and Shaffer wrestled for another pistol, Pasta shot Evarts in the face. Incredibly, Evarts still did not go down. He staggered down the embankment to retrieve another gun from the wrecked car. Pasta caught up with him and smashed his head with the butt of the rifle.

In the meantime, Palmer grabbed a wrench from DeCarlo's car and struck Shaffer in the face. He did not realize that Mrs. Kash had snuck up behind him with another wrench. She slammed it down on his head, and the dazed Palmer made one last effort to retrieve one of the pistols he had dropped in DeCarlo's car. Before he could reach it, Chief Hartman burst on the scene and subdued him.

More police arrived, and in the wrecked getaway car they found plans for more robberies and more firearms. Evarts was dead. The severely wounded Feelo died the next morning in the hospital. Only Palmer survived. He was put on trial and convicted of armed robbery. He was sent back to Rockview to serve a seven-year sentence, but he was released in four.

A FIERY-EYED PHANTOM

An unusual ghost story appeared in a Pottsville newspaper in November 1875. The paper stated that the story was originally reported in the *Mechanicsburg Journal* a few days earlier. It told of a strange apparition that visited a Mrs. Nesbit, who lived in Warrington Township, York County. The trouble started one day after a woman with a burned arm appeared at Mrs. Nesbit's door. The strange woman said that she was tired and asked if she could spend the night at Mrs. Nesbit's house. Mrs. Nesbit thought that the request was odd and refused. Before leaving, the woman asked Mrs. Nesbit how she would feel if she were not allowed to rest.

Mrs. Nesbit thought nothing of the incident at first, but she soon began to see something that was quite frightening. A ghostly, humanlike face with fiery eyes began floating from room to room inside her house. After seeing the apparition for several days, she was stricken with rheumatism so severe that she could not rest or sleep. Eventually, her condition improved, but she continued to see the fiery eyes.

Next, the full body of the ghost began materializing in her bedroom late at night. The phantom tore the sheets and blankets off of her bed and hurled her into the corner of the room, where she went into convulsions and passed out. The menacing, fiery-eyed ghost continued to appear every night, disturbing Mrs. Nesbit's sleep. Desperate for relief, she asked some of her neighbors to stand watch while she

slept. The ghost did not seem to mind the audience, and it continued its nightly harassment. The neighbors all saw the fiery eyes clearly and confirmed Mrs. Nesbit's story.

Mrs. Nesbit's friends advised her to seek the help of a local powwower named Dr. Gusler. He was widely known for removing hexes and spells. He instructed Mrs. Nesbit to pass a red-hot sickle up and down over her arm, as close as possible without burning it. Then he instructed her that if someone showed up at her door and asked for something, she should not give the stranger anything and send her away. Sure enough, the next day the woman with the burned arm returned and asked for some lard to grease her wound. Mrs. Nesbit sent her away, and the fiery-eyed phantom was not seen again.

TEETH RUINED BY WATER

A dentist who had recently set up shop in Pittsburgh in 1883 took the time to alert the *Pittsburgh Commercial* about the terrible effect that the water of the Allegheny River was having on people's teeth. He claimed that he had never seen a higher incidence of white decay and crumbling teeth in any other city where he had practiced. He blamed the high acidity levels of the river for the problem and advised everyone to drink limewater to prevent damage to their teeth.

THE RINGING ROCKS

In the middle of the forest in Upper Black Eddy, Bucks County, lies an enormous seven-acre field of rocks and boulders. What makes the rocks different from others is the fact that many of them produce a tone or make a ringing sound when they are hit with a solid object, such as a hammer. The geological anomaly was formed about twelve thousand years ago when the glaciers receded. The field is at least ten feet deep and probably deeper. Somewhere between 10 and 30 percent of the rocks make a clear ringing sound. It is not known why the others, which have the same geological characteristics, do not.

Another strange characteristic of the field is that birds are almost never seen flying overhead, though this may be due to the lack of food in the area. Various theories have been put forward over the last century to explain the ringing, from internal stresses in the rock to the suggestion that they are some type of meteor fragments. None has sufficiently explained the musical rocks.

THE HEX MURDER

The story of the hex murder begins early in the twentieth century with a young powwower named John Blymire. Blymire was continuing a tradition that dated back three generations in his family and perhaps longer. Though he

had been considered slow in school, he became known for his cures and healing remedies and established a good reputation in York County at a young age. However, things started to change after he apparently cured what was believed to be a rabid dog. Blymire became convinced that someone had placed a hex upon him. He could no longer eat, sleep or continue his practice as a powwower. All attempts to remove the hex failed. Then, one sleepless night, he figured out the identity of his tormentor. At the stroke of midnight, an owl hooted seven times. Blymire knew that the hex had been placed on him by the spirit of his great-grandfather Jacob, who had been the seventh son of a seventh son. To escape the curse, he moved away from the family home and cemetery where his great-grandfather was buried.

Blymire returned to normal and continued his practice, working mundane jobs to support himself. A few years later, he got married. He had two children, but they both died in infancy. The second lived for only three days. Blymire came to believe that he had been hexed again. He sought out other powwowers to help him remove the curse, but none of their remedies was successful. One of them was Andrew Lenhart. Lenhart convinced Blymire that someone he knew well had placed the hex on him. Blymire's wife began to fear for her safety because shortly before, in 1923, one of Lenhart's other clients had murdered his spouse, who had allegedly hexed him. Her family consulted a lawyer, and they received a judge's order to have Blymire mentally

evaluated. After the evaluation, the judge had Blymire committed to a mental institution because of his obsession with hexes and magic. His wife divorced him. Blymire was only in the facility for forty-eight days before he simply walked out due to lax security.

Blymire, still obsessed with finding the identity of the person who had hexed him, sought out help from one more powwower. Mrs. Knoll (aka Mrs. Knopt) was retired but agreed to work with Blymire in a series of sessions. Blymire soon learned that an old man he had known since childhood had placed the hex on him. Finally, Mrs. Knoll revealed the man's name—Nelson Rehmeyer—another powwower who had removed a hex from Blymire as a child. To remove the hex, Blymire would either have to steal Rehmeyer's copy of the powwow book *The Long-Lost Friend* or cut a lock of his hair and bury it six feet underground.

During the sessions with Mrs. Knoll, Blymire also learned that the Hess family and a man named John Curry had been hexed by the sixty-year-old Rehmeyer. Blymire met with the others and convinced them to take action. On November 27, 1928, Blymire led Wilbert Hess and John Curry into Rehmeyer's Hollow and to the powwower's house. The three men broke in and demanded that Rehmeyer turn over his copy of *The Long-Lost Friend*. When he did not turn over the book quickly, they tackled him and held him on the ground. He promised to retrieve the book if they released him, and they did. At their trial, the men claimed that Rehmeyer then attacked them, and all three men began to

beat him. Soon, they realized that he was dead. They never found his copy of the book. The men put Rehmeyer's body in a mattress and set it on fire.

The fire did not destroy all of the evidence, and the men went to trial. Blymire and Curry received life sentences, and Hess received a ten- to twenty-year sentence. All three men were eventually paroled and ended up living fairly normal lives. Curry went on to serve during World War II. The sensationalism of the trial drove the traditional practice of powwowing underground and added to negative stereotypes of the Pennsylvania Dutch. Powwowers became associated with black magic in the public eye, and its practitioners were portrayed as backward.

OMENS OF DEATH

The Pennsylvania Germans had many superstitions about death. Those superstitions varied depending on what county they were in and what part of Germany they came from. A visitor to Pennsylvania Dutch country in the 1700s and 1800s would have encountered myriad sayings in regards to omens and portents of death. Here are just a few:

If you get sick on Sunday, your illness will be fatal.
If a picture falls off the wall, it means someone will die.

If a crow crosses your path on the street, you will soon be attending a funeral.

If a clock suddenly stops, there will be a death.

If a fruit tree suddenly blossoms in the fall, someone will die.

If you miss a row while planting onions or while sowing grain, you will die before the year is over.

If there are funerals between Christmas and New Year, there will be many funerals throughout that year.

If birds fly into a house, it could be a sign that someone will die.

If a hen crows, there will be a death.

If the singing at a funeral is bad, there will be another funeral.

If an owl hoots next to a house, someone will die.

Omens like these may make you not want to get up in the morning. But if you stay in bed and are not feeling well, don't pull on your sheets and blankets, because if a sick person does so, he will die.

HE WAS A COMMUNIST FOR THE FBI

By all appearances, Matt Cvetic was a normal middle-class man living in Pittsburgh. Born in 1909 to Slavic immigrants in the neighborhood of Lawrenceville, Cvetic was one of eleven children. Though he had some education, he never seemed to hold a job for very long. Cvetic had a troubled

marriage that ended in divorce, partly because of his drinking problem and philandering. In 1939, he tried to join the army to work in intelligence. He was rejected.

In the spring of 1941, Cvetic's luck began to change. The FBI was looking for informants to infiltrate the Communist Party in Pittsburgh. Cvetic accepted the difficult assignment, even though it meant that he would have to publicly express sympathies toward communism. By 1943, Cvetic had successfully become a member of the party, attended meetings and even sold the party newspaper, the *Daily Worker.* He participated in protests and marches and became so vocal that the FBI asked him to tone it down so as to not attract suspicion. During his time with the party, Cvetic sent the FBI thousands of pages reporting on meetings, members and publications of the Communist Party. He was considered one of the FBI's most productive informants. His work would be used in prosecutions, and later he would testify before the House Un-American Activities Committee.

Cvetic's activities continued to take a toll on his private life. His mother died believing that he had become a communist. His own sons disowned him while he was undercover. He was fired from his job at the Civil Service Commission for being a communist.

Then things began to fall apart with his undercover work. By the late 1940s, Cvetic had revealed his FBI affiliation several times while intoxicated. After he committed other violations of his agreement, the FBI discontinued his service in 1950. Cvetic always claimed that he had quit because he

had spent too much time undercover. The FBI refused to publicly issue a report stating that he had been employed by the bureau, so he allowed his story to reach the press after he was called as a federal witness. He exaggerated his exploits and the value of his information, as well as the danger that he regularly faced. He served as a witness in several important trials after leaving the employment of the FBI, but his testimony soon became unusable because he became a "professional witness." His only source of income and pride was to tell his increasingly exaggerated version of his story to whoever would listen.

For a brief period of time, he became a celebrity. Mayor David L. Lawrence declared April 19 Matt Cvetic Day in Pittsburgh in 1951. There was a luncheon for the city's prominent officials and a parade in Cvetic's honor. His life even inspired a movie and subsequent radio show entitled *I Was a Communist for the FBI*. Unfortunately for Cvetic, he was not prepared to deal with the sudden fame. His exaggerations of his activities became so bad that the FBI distanced itself from him as much as possible, and many of his new friends began to back away as his credibility waned. By 1955, he was no longer being called as a witness. His own book about his exploits, *The Big Decision*, sold well enough but did not bring the profits that he expected. It seemed to be based more on the movie than on real life. Tales of his dysfunctional personal life surfaced in the press, and Cvetic sank back into relative obscurity. He died of a heart attack in 1962 while in California, but he was buried in Pittsburgh.

About the Author

Thomas White is the university archivist and curator of special collections in the Gumberg Library at Duquesne University. He is also an adjunct lecturer in Duquesne's History Department and an adjunct professor of history at La Roche College. White received a master's degree in public history from Duquesne University. Besides the history of Pennsylvania, his areas of interest include folklore, public history and American cultural history. He is the author of *Legends and Lore of Western Pennsylvania*, also published by The History Press.